IMAGES
of America

VALLEY STREAM

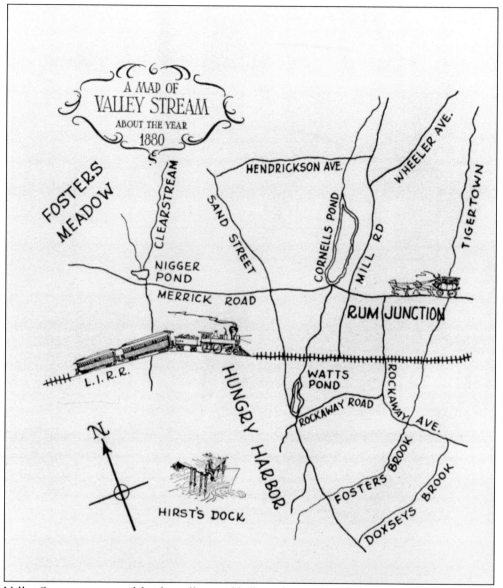

A MAP OF VALLEY STREAM ABOUT THE YEAR 1880

FOSTERS MEADOW

CLEARSTREAM

HENDRICKSON AVE.

SAND STREET

CORNELLS POND

WHEELER AVE.

TIGERTOWN

MILL RD

NIGGER POND

MERRICK ROAD

RUM JUNCTION

L.I.R.R.

HUNGRY HARBOR

WATTS POND

ROCKAWAY ROAD

ROCKAWAY AVE.

FOSTERS BROOK

DOXSEYS BROOK

N

HIRST'S DOCK

Valley Stream was named for the valleys and hills in the north and the streams in the south of Long Island. Many waterways crisscrossed the village (with most incorporated into the Brooklyn Water Works system), including Foster's Brook, Doxsey's Brook, Clearstream, Watt's Pond, and Cornell's Pond. Around 1880, the neighborhoods of Rum Junction, Tigertown, and Hungry Harbor were prominent, and the village's major streets were laid out, including Central Avenue (Sand Street), Rockaway Avenue, Roosevelt Avenue (Rockaway Road), Merrick Road, Corona Avenue (Mill Road), Wheeler Avenue, and Hendrickson Avenue. (Courtesy of the Valley Stream Historical Society.)

ON THE COVER: Village officials and residents watch as ground is broken on Rockaway Avenue for Salvatore Calderone's Valley Stream Theatre in early 1926. The theater would become known as the Rio and would stand on the corner of Fairview Avenue until the mid-1990s. (Courtesy of the Long Island Studies Archive at Hofstra University.)

IMAGES
of America

VALLEY STREAM

Bill Florio

ARCADIA
PUBLISHING

Published by Arcadia Publishing
Charleston, South Carolina

Printed in the United States of America

Library of Congress Control Number: 2014941800

For all general information, please contact Arcadia Publishing:
Telephone 843-853-2070
Fax 843-853-0044
E-mail sales@arcadiapublishing.com
For customer service and orders:
Toll-Free 1-888-313-2665

Visit us on the Internet at www.arcadiapublishing.com

*Dedicated to all Valley Stream residents who were
ever curious about the history of their village*

CONTENTS

Acknowledgments

This book could not have been completed without the support, help, and contributions of these wonderful people: Guy Ferrara, James Borzumato, Carol McKenna, Mayor Edwin Fare, Judge Robert Bogle, Kathy Bogle, William Stris, Robert Blakeman, Joseph Foarile, Gregory May, Amy Bentley, Amaka Oweazim, David Sabatino, Officer Steven Zacchia, Martin Elias, county executive Edward Mangano, Brian Nevin, Richard R. Walker, Peter DiSilvio, Ann DeMichael, Douglas Pascarella, Art Mattson, Barbara Gribbon, Dan King, Carol Grassi, John Logerfo, Caitlin McGurk, Joe Hepworth, Edward J. Smits, Iris Levin, Walter Itgen, Michael A. Florio, Michael E. Florio, Peter Bauer, Katie Grilli-Robles, Andrew Hackmack, Brian Donnelly, Marie Roman, Caitlin Scholl, Ryan Broderick, Joseph Gathard, Randy Gregg, Michael Schutzman, Jacqueline Hlavenka, Delia Paunescu, Robert Haber, Michael Frollo, Samuel Rubenfeld, Stefanie Gray, Nick from the Building Department, Maryann Cahill, my parents William F. Florio and Cathy A. Florio, and of course, my ever-patient editor, Abby Walker.

INTRODUCTION

The land that became Valley Stream did not have a name until the mid-19th century. The northern portion, near Elmont, was referred to as Foster's Meadow and the southern part as Near Rockaway. In the southwest, the swampy squatters community was called Hungry Harbor. In general, the whole area was called the land between Jamaica and Hempstead.

The first documented activity in what would become Valley Stream, the Pea Soup Affair, occurred during the American Revolution. The town of Hempstead was fiercely Tory, and Isaac Denton and Isaac Smith plotted to poison Gen. George Washington's pea soup to ensure a British victory. John Hendrickson of Valley Stream discovered the nefarious plan and alerted local colonial authorities who then pursued the pair to Hungry Harbor, where they escaped.

Robert Pagan moved to Valley Stream from New York City after emigrating from Scotland and set up the village's first general store on the corner of present-day Henry Street and Hendrickson Avenue. That intersection became the village's first town center. Mills began popping up along the dirt roads. The Wright family built a sawmill around today's North Corona Avenue and Morris Parkway and a gristmill on North Corona Avenue where it meets Franklin Avenue. The Cornell family set up a mill on the corner of modern-day Mill Road and Sunrise Highway.

Pagan saw a problem with the mail delivery system. To retrieve mail, farmers had to travel miles to Hempstead, losing precious daylight hours. In 1848, Robert Pagan proposed establishing a post office branch in his general store. He looked towards the valleys and hills in the north and the streams in the south and created the name Valley Stream for the mailing address. It stuck.

The increased population along Long Island's south shore led to the construction of a new plank road to alleviate the traffic on Hempstead Turnpike. The Merrick Plank Road was built in 1853, allowing residents from Jamaica and the south shore to travel to the Methodist camp in Merrick. When the road came through Valley Stream, the village's downtown shifted to the corner of modern-day Merrick Road and Central Avenue.

Ellen Pagan, Robert Pagan's wife, formed the first church in Valley Stream inside the Pagan homestead on Hendrickson Avenue. When the community outgrew that location, they opened the Sinner's Hope Chapel on the land where Wheeler Avenue School now sits. That congregation has evolved over time into the current Grace United Methodist Church.

New neighborhoods took shape in previously unsettled parts of the land. Tigertown was a squatter's community that first appeared around 1880, known for drinking and fights. Shanties and other dwellings were built from old soapboxes and barrel staves. Years later, in 1903, the community's "mayor," Jake Golder, tried to fight off the sale of the squatters' land by John Miller and Christopher Schrieber, who wanted to develop it.

Cookie Hill was another squatter community known for its ladies of ill repute, including two named Black Sue and Speckled Elsie. Nearby Skunk's Misery was named for the smell of a fertilizer plant. Rum Junction became the lively area that arose around Rockaway Avenue and the railroad.

The South Side Railroad came through Valley Stream in November 1867, connecting Jamaica to Babylon. Though the railroad did not stop there until 1869 when the Far Rockaway branch opened, Valley Stream's downtown shifted to Rockaway Avenue surrounding the tracks. The Rum Junction area was filled with hotels and taverns where riders waiting for a train could get a drink or spend the night.

The Brooklyn Water Works and New York City Water Company built their aqueduct system from the Ridgewood Reservoir in Queens through Valley Stream along the future route of Sunrise Highway, past the Milburn Pumping Station in Freeport to Massapequa Lake. Most of the ponds and streams in Valley Stream were once part of the system. Sunrise Highway was built in 1928 over the conduit line, and the village was deeded all the remaining watershed properties (including the Village Green) in 1989. The steep hill under the railroad tracks on Hicks Street and Central Avenue is the buried conduit line.

By the 1920s, residents of Valley Stream were interested in incorporating as a village. The first election for incorporation was held on September 14, 1922, at the Corona Avenue firehouse. It passed by eight votes, but that was deemed an insufficient majority. A second election was held on November 9, 1922, in Jacob Ruehl's barbershop, but the proposal was defeated by a large number of votes. A third attempt on January 30, 1925, at the Corona Avenue firehouse brought an overwhelming majority out for incorporation: 669 voted for and only 293 against the measure.

The village drew its boundaries as the fire district lines and intentionally left out the marshy Hungry Harbor area, believed to be useless property. They opened the village offices at 34 West Merrick Road on May 21, 1925.

Development began in Valley Stream in earnest. The Gibson Corporation started building houses along the Roosevelt Avenue section in 1922 and later along Cochran Avenue and Dartmouth Street in 1927. William Gibson even convinced the Long Island Rail Road to put a stop in his new development. In 1929, Gibson Station opened.

New roads and neighborhoods were appearing all over town, including Wallendorf Park, Ormonde Park, Fairhaven Park, Irma Park, and Rosedale Garden. Previously unmapped roads and road names were coming into use as other thoroughfares changed names. By the turn of the 20th century, Sand Street became Central Avenue, Mill Road became Corona Avenue, Rockaway Road was now Roosevelt Avenue, New York Avenue was renamed Valley Stream Boulevard, Linden Street was now Gibson Boulevard, Hempstead Avenue became Fairview Avenue, Merrick Avenue became Lincoln Avenue, and Milton Avenue turned into Hawthorne Avenue. Roads also disappeared from maps, as Third Street, Eighth Street, and Montague Terrace were taken over by development. At some point, Elmwood Street became Hicks Street and Second Street became Legion Place.

Air travel came to Valley Stream with the 1928 opening of Rogers Airport on the former Reisert Farm. Within the next year, the airport became Curtiss Field and was the most popular airfield on Long Island. After years as an airplane manufacturer with Columbia Aircraft and Commonwealth Aircraft, the Chanin organization purchased a large parcel of the land and built the community of Green Acres and the Green Acres Mall. The Green Acres community would later change its name to Mill Brook.

D.W. Griffith came to Valley Stream in 1911 to film his short *The Stuff Heroes are Made Of*. All prints of the film have been lost to time, but this was only the beginning of Valley Stream's flirtation with Hollywood. Valley Stream natives Steve Buscemi and Edward Burns filmed their intensely personal films *Trees Lounge* and *The Brothers McMullen*, respectively, in Valley Stream. Valley Stream was even used in some scenes of *Goodfellas* and numerous independent films. Buscemi's film was based on the notorious Trees Lounge bar in Valley Stream on the corner of North Central Avenue and Lutz Drive; however, the bar scenes themselves were filmed in Queens. Other movie, music, and television stars who have called Valley Stream home include John Bunny, Fred Armisen, Jim Breuer, Everlast, Shaggy, Larry Miller, Michael Brandon, and lead singer of the Gin Blossoms Robin Wilson.

Over the years, many businesses have based their headquarters in Valley Stream. Snapple was first produced in Valley Stream and had its headquarters on North Central Avenue near the corner

of McKeon Avenue. Its spokesperson for most of the 1990s, Wendy Kauffman, was also from Valley Stream. Bulova Demco operated its business out of the old Curtiss Field hangers for a number of years, and Wetson's and Cooky's Steak Pub both worked out of the current Minerva and D'Agostino building on South Central Avenue. The Colonial Insurance Corporation building stood tall over the village south of Sunrise Highway near the train station. Its large letters were a landmark to incoming train passengers. The Valley Stream Sanitarium acted as a hospital for years at the corner of Benedict Avenue and Merrick Road.

For a time, Valley Stream was filled with bowling alleys, movie theaters, restaurants, and bars. The Valley Stream Bowl sat at 40 East Merrick Road until the early 1990s, the Pavillon Lanes Bowling Alley was on the corner of West Merrick Road and South Montague Street until the mid-1960s, and the Green Acres Bowl was demolished around the middle of the 1980s. Five movie theaters called Valley Stream home, including Doc Muller's theater room on the second floor of his building on the corner of Rockaway Avenue and West Jamaica Avenue. The Sunrise Drive-In was torn down in 1979 and became the Sunrise Multiplex, and the Green Acres Century Cinema split itself into multiple screens in the early 1980s before it was demolished in 2012. The Belair Theatre was opened in the early 1960s by B.S. Moss as a small art house, revival, and B-movie theater in the Hills Shopping Center on West Merrick Road (today's King Kullen shopping center). It was split into a twin in 1977 and torn down in the mid-1980s. Finally, the Rio Theatre on Rockaway Avenue was the premier theater in Valley Stream and transformed into a performance space in the 1980s.

Bars and pubs could be found throughout Valley Stream. The CC Pub (later Echoes and the Foxy Hutch) was on the corner of Central Avenue and West Merrick Road. The Publick House (originally the Gateway Inn) was on Sunrise Highway between Seventh Street and Sixth Street. Guys and Dolls opened in the late 1960s as a pool hall at 175 East Merrick Road. Buckley's under the railroad tracks first opened in 1969, and its neighbor, Railroad Inn, opened earlier that year. Larry's Pub (the Club Bar) on Rockaway Avenue opened in 1955. Cantina Café at 64 East Merrick Road opened in 1970. The Starlit Inn was on the corner of Woodlawn Avenue and Rockaway Avenue next to Jack's Candy Store. Trees Lounge was on the corner of Lutz Drive and North Central Avenue. St. Stephens was farther up North Central Avenue. The Central Inn was in a row of stores on the west side of South Central Avenue down the block from Village Hall. The Patio was in front of the Sunrise Drive In. The Rendezvous was on Mill Road in the block of stores by Jedwood Place. The Rock Face Tavern was on West Merrick Road between Liberty Boulevard and Green Street. Terry O's was near the corner of Rockaway Avenue and West Merrick Road. The Valley Stream Inn stood at 58 Rockaway Avenue and later turned into the Nite-cap and is currently PJ Harpers. Coakley's was located on the corner of Rockaway Avenue and Roosevelt Avenue across the street from Phil's Tavern. Tiffanany's was in the basement of the Brookside Apartments. Other bars that existed in Valley Stream over the years include Bits n Pieces and Club 600.

Past restaurants in Valley Stream include The Lamp on the corner of Sunrise Highway and Adeline Place (originally Uncle Joe's Cocktail Lounge). Marty's Diner (also called Chef's) was on East Merrick Road where the Nassau Educators Federal Credit Union stands. The Rainbow (later Paul's) Diner was on West Merrick Road and the corner of Fletcher Avenue. The Lamplighter, one of the first clubs with black musicians, was on Fifth Street where Inatome is now. Edward's (originally Peter Luger's and Edouard's) was located on the corner of Brookside Drive and Sunrise Highway. The Tulsa Diner (also called the Flagship Diner and now the Concord Diner) was on Sunrise Highway and Fourth Street. The Coral Inn (later Carlucci's and Legz) was where Sunrise Highway met Brooklyn Avenue. In the 1950s, on the corner of Sunrise Highway and Woodlawn Avenue, Pizzaworld was housed in a railcar diner. The Porterhouse was on Central Avenue and West Merrick Road in Tom West's Hotel. Jack's Pizza was on Rockaway Avenue near the corner of East Mineola Avenue. Casatina and Goldie's were in different buildings at Gibson Station. Zebra's was on Rockaway Avenue between Merrick Road and Lincoln Avenue. Murphy's House was at 56 West Merrick Road. The Bird Cage, a notorious drag club, stood proudly on Merrick

Road and Emerson Place. Carl Hoppl's Valley Stream Park Inn was across from the pool, not to mention the many roadhouses on Merrick Road, including Club Esquire, Hoffman's, Pavillon Royal, and The Lodge.

Other businesses of note in Valley Stream's recent history include Brown's Hardware and Jenna's Bakery on Rockaway Avenue above Fourth Street, Central Hardware on North Central Avenue above Stein Street, Ed's Aquarium on Scranton Avenue between Bismark Avenue and Horton Avenue, Brancard's Deli on Rockaway Avenue and West Fairview Avenue, and Wood's Locksmith down the block. Community Market was located on Rockaway Avenue opposite Miriam Street and the Zirkel Funeral Home. John Frich's deli and Morrows Pharmacy were on opposite ends of that same building. Bohacks was on the corner of Roosevelt Avenue and Rockaway Avenue, near Ruehl's Barbershop and Ferber's Drugstore. Guido's Deli and the Campus flanked Rockaway Avenue opposite the end of Lee Avenue. Kelly's Candy Store sweetly stood on the corner of Rockaway Avenue and Sunrise Highway. Sandy's was on the corner of Roosevelt Avenue and First Street. Baranburg's Bakery was on Rockaway Avenue, down the block from Polychron's. Schramm's Bakery was on Rockaway Avenue and Jamaica Avenue. Phil Amy Florist was on Rockaway Avenue south of Merrick Road. Pastosa, Harry & Flo's, Cullys, and Everbest Bakery were on North Central Avenue north of Hendrickson Avenue. Boening Florist was on Merrick Road west of Central Avenue. Fortunoff's and Pier One Imports occupied the building that is currently Staples. Wonderama still stands on Rockaway Avenue and Fifth Street. Stonie's is at Gibson Station. Gunther's Bicycle Shop was on North Central Avenue and the Schwinn shop on Merrick Road and Cottage Street. Granado Appliances was at 800 West Merrick Road and closed only recently. Whitey's Soda Shop sat next to Suprina's on Rockaway Avenue, while down the street, Teddy's opposed Elegant Junk and the Lantern Shop.

Like all of Long Island, Valley Stream has had its share of dark moments. The revival of the Ku Klux Klan in the 1920s did not escape Valley Stream. The Klan's targets were the Catholic immigrants that were arriving in the village, particularly the Gibson area, and cross burnings did happen on occasion. On October 12, 1923, the Klan burnt crosses in dozens of villages across Long Island, Valley Stream included. On September 26, 1934, they held a rally and parade on Hoffman Street. The first Klan funeral on Long Island occurred on Merrick Road, where the Pioneer Klan No. 3 (or Valley Stream Social Club as they called themselves) carried the body of John Kearsch of Valley Stream to a cemetery in Elmont. Public outrage over the Klan's actions and presence even reached Village Hall. In 1927, voters ousted out all incumbents, including Mayor Louis Hicks, whom they claimed was a supporter.

The Lonely Hearts Killers, the subject of a movie starring John Travolta and James Gandolfini, also lived in Valley Stream. Raymond Fernandez and Martha Beck murdered 20 women between 1947 and 1949, most of whom they met through lonely-hearts advertisements in newspapers. In Valley Stream they lived at 15 Adeline Place, where they committed many of the murders for which they were convicted. They were executed on March 8, 1951.

Valley Stream also made the news with Fred McManus, who killed five people on a murder spree between March 27 and March 31, 1953. He was sentenced to life in prison but released after 20 years. On March 3, 1989, a 21-year-old Robert Golub murdered his 13-year-old neighbor Kelly Ann Tinyes of Horton Road. Her grisly death is still a sore subject in the neighborhood. The Tinyes murder was the first case in New York that DNA evidence was used to win the case. The December 1990 Sunrise Cinema shooting was another black spot in the village's past.

Through good and bad, Valley Stream has developed immensely since its years as a bucolic farm community. Valley Stream today is a urban and suburban hub and full of more life than ever before.

One

PRE INCORPORATION

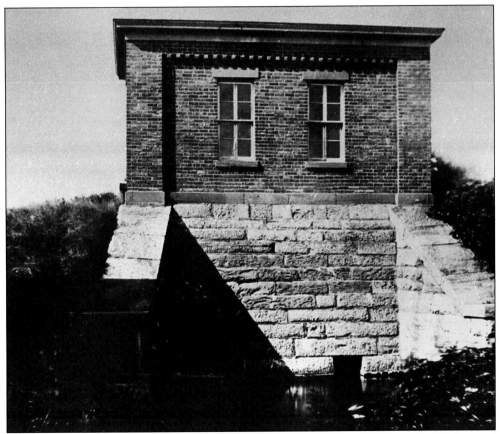

Brooklyn and New York incorporated the ponds and streams on Long Island in their Ridgewood Reservoir system. In 1853, they set up pumping stations at Cornell Pond, in 1859 at Watts Pond, and in 1885 on Clear Stream. This Brainard Plate from 1874 shows the Culvert & Wash Gate in the conduit. (Courtesy of the Nassau County Photo Archives.)

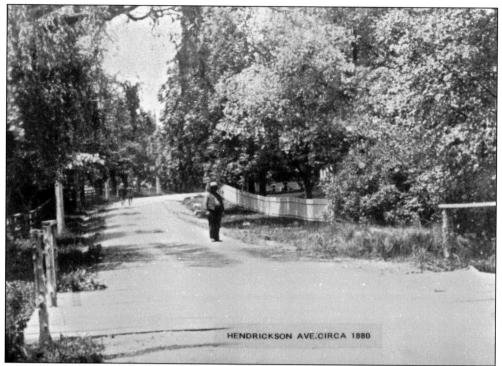

HENDRICKSON AVE. CIRCA 1880

When Valley Stream was formed, the center of town was the corner of today's Hendrickson Avenue and Henry Street. This shot, looking west along Hendrickson Avenue in the 1880s, shows people walking away from the town center and passing the stream that currently connects Hendrickson Park and Valley Stream State Park. In the background of the picture stands the Pagan homestead. (Courtesy of the Valley Stream Historical Society.)

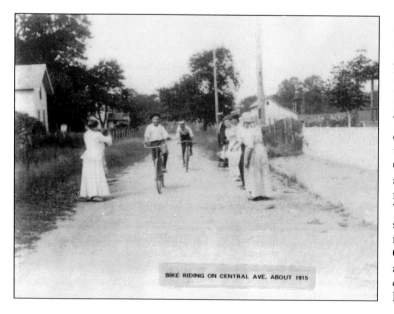

BIKE RIDING ON CENTRAL AVE. ABOUT 1915

Valley Stream became a prime destination for bike riders around the turn of the 20th century. There were two dirt tracks around the intersection of Central Avenue and Merrick Road named Etlick's Oval. This photograph shows children riding bicycles down Central Avenue about 1915. (Courtesy of the Valley Stream Historical Society.)

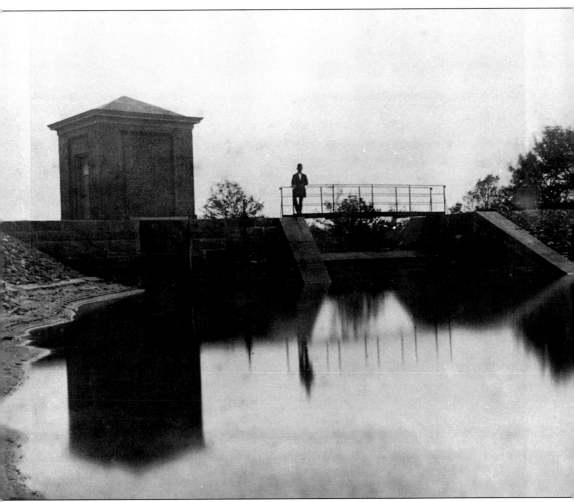

The conduit ran from the Ridgewood Reservoir in Queens through Valley Stream along the future route of Sunrise Highway, passing the Milburn Pumping Station in Freeport to Massapequa Lake. The City of Brooklyn built a dam and spillway at Merrick Road on Cornell's Pond and made it the Valley Stream Supply Pond. An aqueduct ran down from the pond through the current Village Green to the main Ridgewood Aqueduct line. Sunrise Highway was built in 1928 over the conduit line, and the village was deeded all the remaining watershed properties (including the Village Green) in 1989. In the 1960s, Carl Hoppl would recreate this 1878 Brainard Plate image in the rebuilding of his Valley Stream Park Inn. (Courtesy of the Nassau County Photo Archive.)

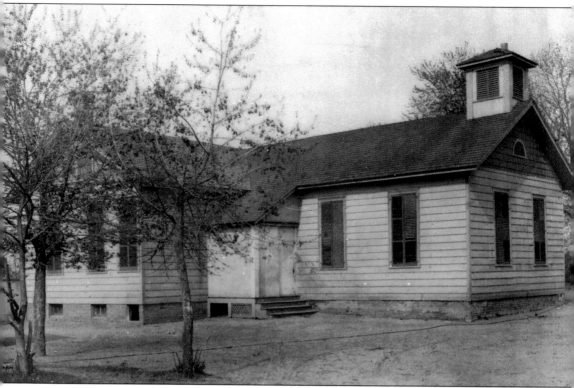

This 1891 two-room schoolhouse replaced the 1859 one-room building farther east on Wheeler Avenue, where Marshall Dibble taught. The school, whose official name was Common School District 13, stood just north of the current Wheeler Avenue school. It was demolished when the 1905 clapboard school on the corner of North Corona Avenue and Wheeler Avenue replaced it. (Courtesy of the Valley Stream Historical Society.)

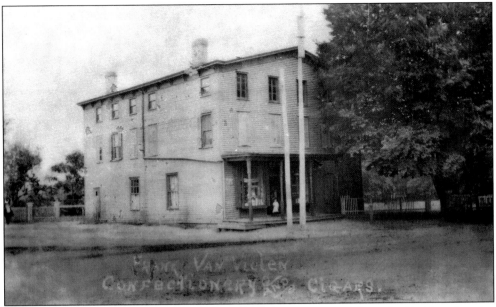

The Merrick Plank Road opened in 1853. Stagecoach lines ran up and down the road from Jamaica to the Methodist Camp in Merrick. In Valley Stream, businesses started popping up on the new road, moving the community's center south. One of the first businesses was James Fletcher's general store, pictured here. (Courtesy of the Valley Stream Historical Society.)

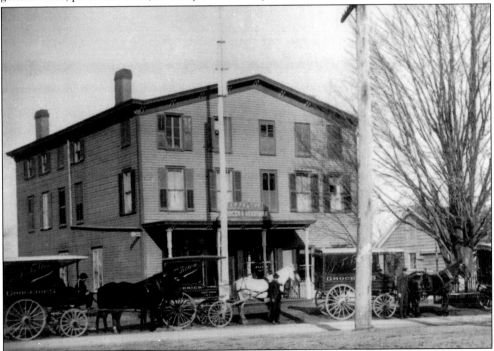

After James Fletcher's death, his store was bought by Joseph Felton and became J.F. Felton Grocer and Seedsman. Seen here in the 1890s, the store was located on the northeast corner of Merrick Road and Central Avenue. It survived into the early 2000s as Rivoli TV and Central Carpet. Currently, a TD Bank sits on its site. (Courtesy of the Valley Stream Historical Society.)

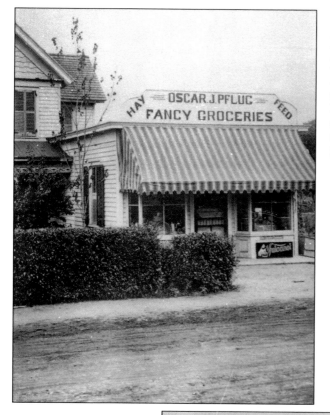

As the village center moved south, Central Avenue began to develop. Oscar Pflug opened his grocery store on Central Avenue north of Merrick Road, across from what is today CVS. Pflug would later become one of the village's first trustees. (Courtesy of the Valley Stream Historical Society.)

This 1915 shot of Pflug & Ackley's Store shows a rare view of the building with a porch and no sign or awning. In the back is a better view of the house on the east side of Central Avenue, just north of Merrick Road. (Courtesy of the Nassau County Photo Archive.)

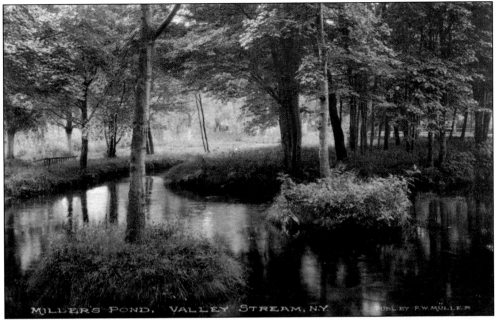

Hattie Miller's Pond sat where the Brookside Apartments are today on Merrick Road. Her long-gone estate stood on the site of the current King Kullen shopping center on the north side of Merrick Road (originally the Hills Shopping Center and Belair Movie Theatre). (Courtesy of the Long Island Studies Archive at Hofstra University.)

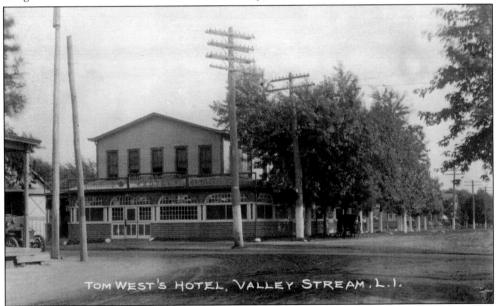

One of the early attractions in Valley Stream was Tom West's hotel on the southeast corner of Merrick Road and Central Avenue. The hotel was an early stagecoach stop on the Merrick Plank Road (along with the Tally-Ho Hotel on Horton Avenue) and attracted attention from bicycling enthusiasts who frequented the nearby tracks at Etlick's Oval. In the 20th century, Tom West's hotel became the Porterhouse Restaurant, and the site is currently a branch of South Nassau Community Hospital. (Courtesy of Barbara Gribbon.)

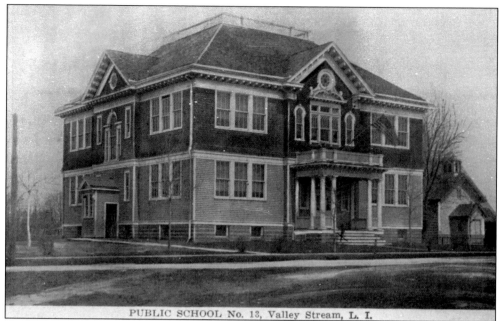

PUBLIC SCHOOL No. 13, Valley Stream, L. I.

District 13's clapboard wooden school building replaced the two-room school in 1905 and sat on the northeast corner of North Corona Avenue and Wheeler Avenue. When the current Wheeler Avenue School was built directly east of it in 1925, the clapboard school became Valley Stream's first Central High School. The building was demolished in 1930 and is currently the Wheeler Avenue schoolyard. Directly to the right in this photograph is Ellen Pagan's Sinner's Hope Chapel. (Author's collection.)

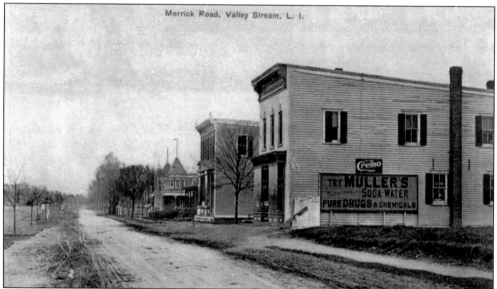

Merrick Road, Valley Stream, L. I.

Before moving to the corner of Rockaway Avenue and Jamaica Avenue, Doc Muller had a drugstore on West Merrick Road, just off Rockaway Avenue. The store, seen here on the south side of the street, stood between Rockaway Avenue and South Corona Avenue. In the background is the corner of Rockaway Avenue and Merrick Road, featuring Peter Luca's hotel. Note that Rockaway Avenue does not cross Merrick Road. (Courtesy of Barbara Gribbon.)

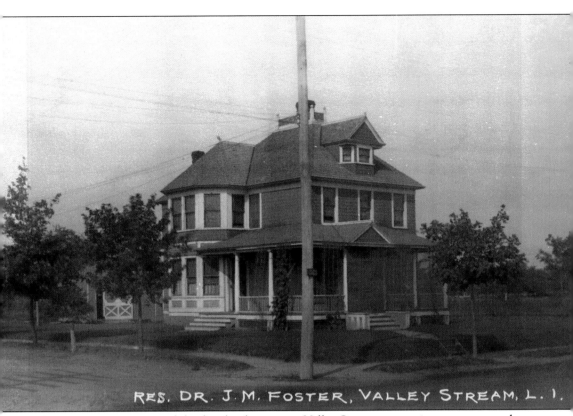

RES. DR. J. M. FOSTER, VALLEY STREAM, L. I.

Abram F. Foster was one of the first landowners in Valley Stream, possessing property on the east side of Rockaway Avenue that borders Foster's Brook (around the current Brookside Avenue and Seventh Street). In 1904, Foster developed parts of Seventh Street and continued it to Rockaway Avenue. He was also instrumental in setting up school district 24 and became one of its first trustees in 1894. His son Dr. J.M. Foster was active with the fire board of commissioners and instrumental in the purchase of the first firehouse on Merrick Road. This image features Dr. Foster's house, which was on the north side of Merrick Road near the intersection of Corona Avenue. (Courtesy of Barbara Gribbon.)

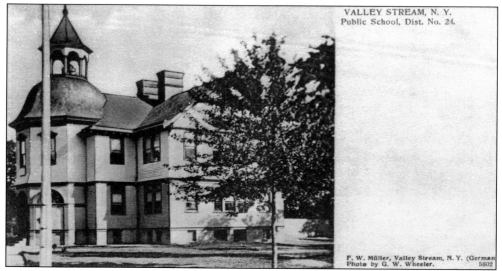

District 24 was organized on September 11, 1894, to provide education for students in the south part of Valley Stream. A one-room schoolhouse was built on the corner of Fifth Street and Brooklyn Avenue, but it was torn down and replaced with this two-story wood-frame schoolhouse in 1898. (Author's collection.)

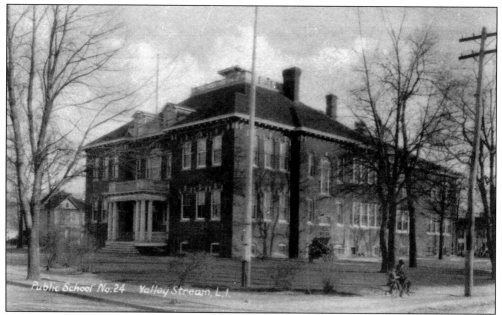

In 1907, the district decided to build a new, eight-room brick schoolhouse on the Brooklyn Avenue site to accommodate the increasing population. The old two-story frame building was moved to the back of the site and was used as an annex until 1913. It is visible at the extreme right of this image. (Author's collection.)

20

The two-story frame building at the back of Brooklyn Avenue School was sold at public auction in 1913 to F. Stanhope Phillips for $345, and eight more classrooms were added to the brick structure for District 24 students. Over the years, more additions were made to the building, including a new gymnasium. Brooklyn Avenue School still stands today on the south side of Brooklyn Avenue, between Fifth Street and Sixth Street. (Author's collection.)

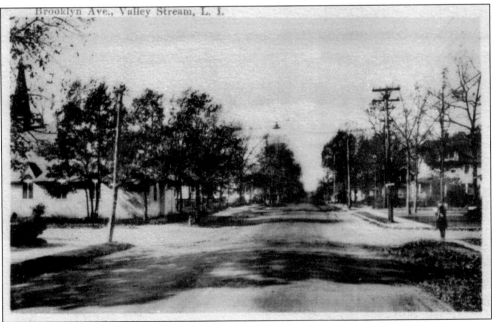

This scene around 1910, facing west on Brooklyn Avenue, shows a dirt road and a few of the older houses. On the left is Holy Trinity Episcopal Church, and beyond that, the cupola to Brooklyn Avenue School is visible. Most of the houses on the right were torn down for Nathan Serota's building. (Author's collection.)

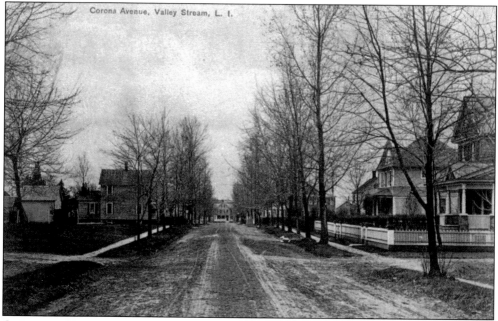

Corona Avenue was still a dirt road up until World War II. Many of the old Colonials seen in this photograph looking south down South Corona Avenue are still standing today. Also, take note of the house at the end of the road on Hawthorne Avenue. (Author's collection.)

A Valley Stream police officer stands in the middle of the intersection of West Valley Stream Boulevard and Franklin Avenue in 1923. Take note of the early traffic light above his head. The Dutch Colonial on the left side would be torn down soon after this photograph was taken, and the Franklin School would be built in its place. (Courtesy of the Nassau County Police Museum.)

Two

ON AND OFF
ROCKAWAY AVENUE

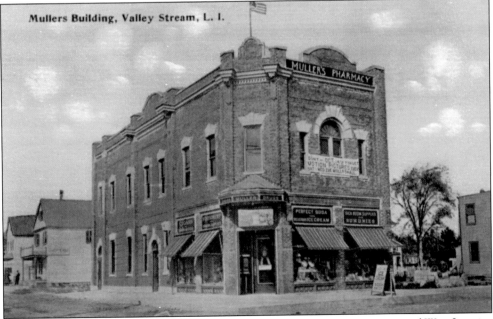

Doc Muller moved his drugstore to the northwest corner of Rockaway Avenue and West Jamaica Avenue. Seen here is the building as it looked in 1912. Doc Muller used the top floor of the building as a movie house, Valley Stream's first theater. After Muller's departure, Frankel and Meyers operated the drugstore. (Courtesy of Barbara Gribbon.)

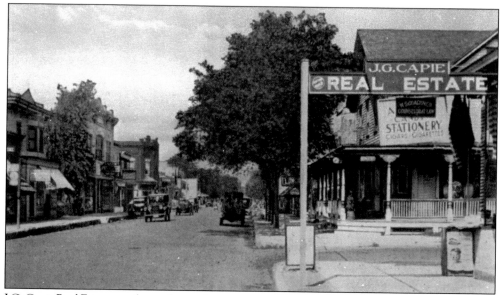

J.G. Capie Real Estate stood near the southeast corner of Hawthorne Avenue and Rockaway Avenue, with its sidewalk-intruding sign. Beneath it, there are smaller signs for an attorney and a stationary and candy store closer to the corner. Across Hawthorne, Landgrebe's Hotel stands high on the street, soon to be replaced by the Valley Stream National Bank building. On the other side of Rockaway Avenue Lang's Dry Goods building has been constructed. (Courtesy of Barbara Gribbon.)

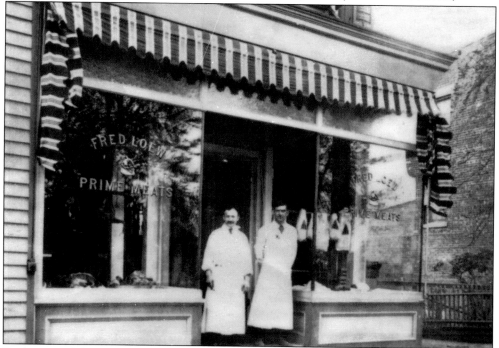

Fred Loew's (left) butcher shop stood in the middle of the western block of Rockaway Avenue between Hawthorne Avenue and Jamaica Avenue. The building has gone through many alterations, including a new storefront in 1941. It is currently the Valley Grocery Mart. (Courtesy of the Valley Stream Historical Society.)

This postcard shows Rockaway Avenue south of Jamaica Avenue in the early 1920s. In the foreground is Tom Kane's ice cream store adjoining Fred Loew's butcher shop. The empty lot beside that would become the home of Lang's Dry Goods, then Morris's Grocery Store, and is now an Associated Supermarket. The Loew's structure stands today (though in altered form) as the Valley Grocery Mart, and Tom Kane's/Glistmann's building was replaced in the mid-1960s. That building burned down in 1973 while occupied by the Valley Stream Market. It is currently Ancona Pizza. (Courtesy of Barbara Gribbon.)

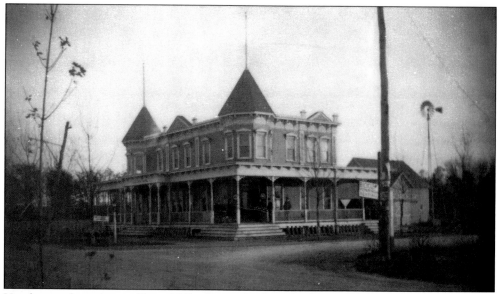

Hotels started popping up all over Valley Stream by the turn of the 20th century, earning Rockaway Avenue the nickname Rum Junction. On the southeast corner of Rockaway Avenue and Merrick Road sat Peter Luca's Hotel, as seen in this 1898 photograph. At the time, Rockaway Avenue did not cross Merrick Road. (Courtesy of the Valley Stream Historical Society.)

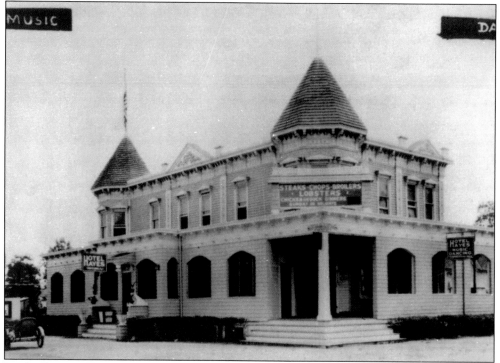

By the Roaring Twenties, Peter Luca's hotel had become the Hotel Hayes and joined the ranks of the other nightclubs and restaurants along Merrick Road known for their entertainment and food. Like many entertainment centers during Prohibition, the hotel was raided numerous times. (Courtesy of the Valley Stream Historical Society.)

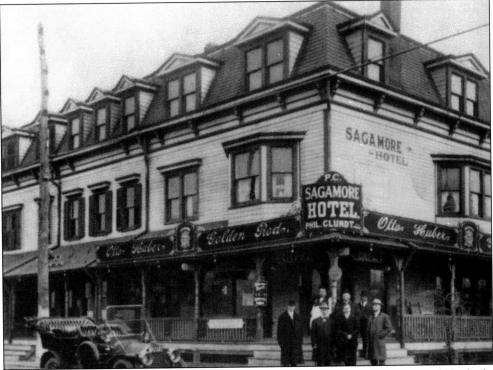

Demand for hotels around the railroad was higher than the speed at which they could be built. The Sagamore Hotel was built on the southeast corner of Hawthorne Avenue and Rockaway Avenue just north of the railroad tracks, in the heart of Rum Junction. (Courtesy of the Valley Stream Historical Society.)

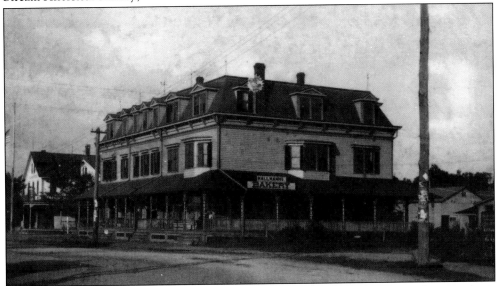

The Sagamore Hotel did not stay under one person's ownership for its entire run. At one point it was Capies Hotel, at another, Dan Bergen's hardware store as well as one of the village's post offices. In this 1936 shot, the building was Mallmann's Bakery. Also take note of the Landgrebe Hotel across Hawthorne Avenue in the rear. (Courtesy of the Valley Stream Historical Society.)

Hotels opened up and down Rockaway Avenue at the turn of the 20th century. The Landgrebe Hotel was situated on the northeast corner of Rockaway and Hawthorne Avenues. Note the sign for "Ales, Wine, Liquors, and Cigars." (Courtesy of the Valley Stream Historical Society.)

Prohibition brought drastic change to Rum Junction. By the 1920s, the "Ales, Wine, Liquors, and Cigars" sign was down on the Landgrebe Hotel and replaced by the generic "Café." Speakeasies opened and were raided regularly in Valley Stream. The site is currently the Valley Stream National Bank building. (Courtesy of the Valley Stream Historical Society.)

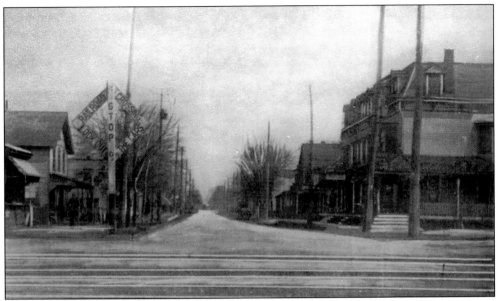

In this picture of Rum Junction looking north, the Sagamore Hotel and the Landgrebe Hotel are both visible. South of the tracks was the Bruns Hotel, later owned by actor John Bunny and Christopher Schreiber and finally by Charles Pitney. The Pitney Hotel (located on the northwest corner of Sunrise Highway and Rockaway Avenue) was demolished in 1952 when Sunrise Highway was widened. (Courtesy of the Valley Stream Historical Society.)

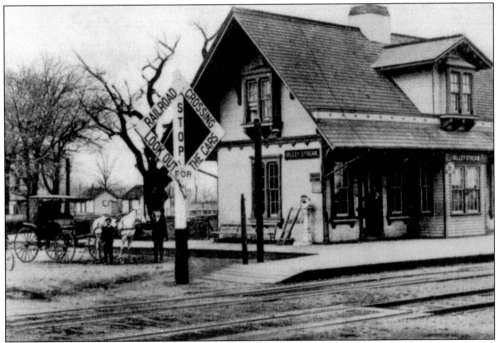

The South Side Railroad ran its tracks from Jamaica to Babylon through Valley Stream in November 1867, but it did not stop until 1869. In 1870, a station was built between Rockaway Avenue and Third Street. When the tracks were elevated in 1933, a new station was built in its current location. (Courtesy of the Valley Stream Historical Society.)

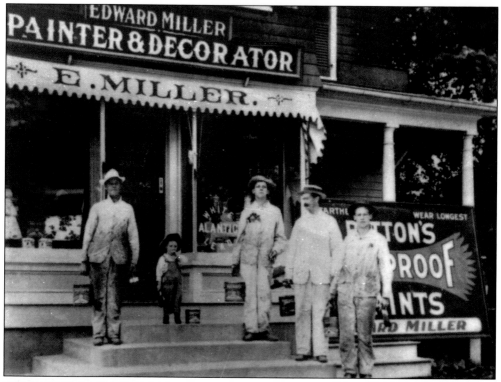

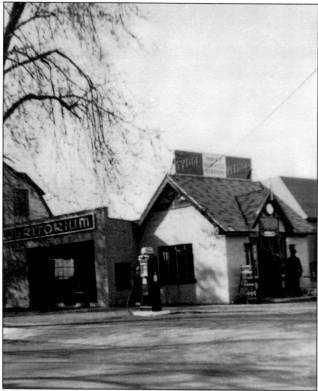

Edward Miller's Painter & Decorator was on Rockaway Avenue around the middle of the business district. Edward Miller is shown standing at left with an unidentified child and three unidentified painters. (Courtesy of the Valley Stream Historical Society.)

Kiki's Gas Station and Lubritorium was first located on the northwest corner of Rockaway and Lincoln Avenues, as shown in this photograph from 1937. Years later, Kiki's Gas Station would move to the northeast corner of Sunrise Highway and Rockaway Avenue, in a parcel adjacent to the Tulsa Diner (currently the Concord Diner). The location of the original Kiki's is still an auto body shop. (Courtesy of the Valley Stream Historical Society.)

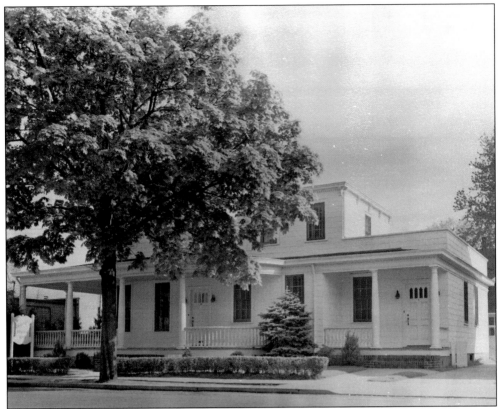

The Miller homestead on East New York Avenue (Valley Stream Boulevard), just east of the corner of Rockaway Avenue, was turned in the Gallagher funeral home in the early part of the 20th century. In 1947, Edward P. Lieber bought the funeral home and his family operates the facility to this day. (Courtesy of Lieber Funeral Home.)

This image from the 1930s captures Rockaway Avenue looking north from the train tracks. On the left is the original Mill Muller, and around the corner is Valley Stream's first A&P. On the right side, take note of the Safeway, the Valley Stream Bank, F.W. Woolworth's, and Teddy's Soda Fountain. (Courtesy of Peter and Beryl Bauer.)

The South Side Railroad built the Far Rockaway branch from Valley Stream in 1869, making Valley Stream a major stop. In 1933, the Long Island Rail Road elevated the tracks and built a new station and Memorial Park at Franklin Avenue. (Courtesy of Peter and Beryl Bauer.)

When the Long Island Rail Road built the West Hempstead branch, the tracks cut from the station to East Merrick Road, separating downtown from a more industrial area. Seen in this 1932 photograph is East Merrick Road looking east toward Lynbrook at the grade crossing. On the right is John Loeffler's lumberyard and house. (Courtesy of Peter and Beryl Bauer.)

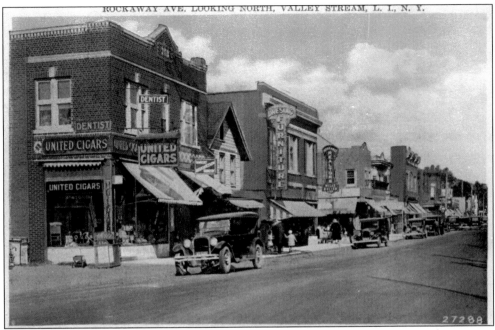

Pictured here is the view from the railroad, looking north at the west side of Rockaway Avenue towards Hawthorne Avenue in the early 1930s. The library can be seen on the west side, and Doc Muller's drugstore and movie house can be seen in the far back on the corner of Jamaica Avenue. Various shops, whose buildings are still standing, can be seen along the street. (Courtesy of Barbara Gribbon.)

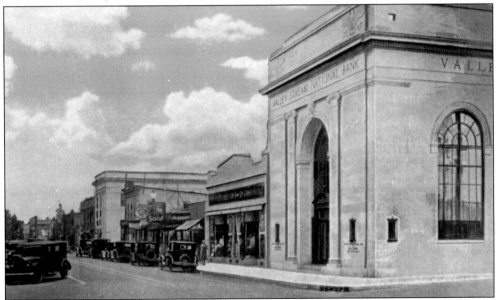

This postcard depicts the east side of Rockaway Avenue looking north at Hawthorne Avenue. The Valley Stream National Bank has found its home on the corner, next to F.W. Woolworth's Five and Dime, which today is Morris Discounts. Farther down the block is Teddy's Ice Cream Parlor and Soda Fountain, which over time would become Paul's Ice Cream Parlor and ultimately Walt Itgen's Ice Cream Parlor. (Courtesy of Barbara Gribbon.)

Outside of the cars, the hanging signs, and the empty lot, this overhead 1930s shot of Rockaway Avenue looking south at Valley Stream Boulevard looks much the same as it does today. A bar stands on the northwest corner (Larry's Pub would replace it in 1955), Polychron's liquor store has started its business on the southwest corner of Rockaway Avenue and Valley Stream Boulevard, and Brock's Hardware is in the building that would become Mitchell's. Frankel & Meyers Pharmacy is in Doc Muller's building on Jamaica Avenue and Rockaway Avenue. The Municipal Building and the Valley Stream National Bank are both in place, and the railroad has been elevated. The majority of buildings in this photograph are all still standing. (Courtesy of Barbara Gribbon.)

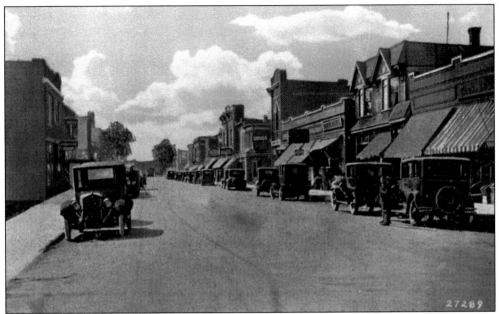

Rockaway Avenue was a bustling business district for many years in Valley Stream, with blocks filled with paint stores, ice cream parlors, real estate offices, pharmacies, butchers, and general stores. Shops displayed hanging signs protruding above their awnings and onto the sidewalk air space, announcing their wares to pedestrians. The village would later ban these hanging signs. This postcard, looking south from Valley Stream Boulevard, shows many buildings still standing today. (Courtesy of Barbara Gribbon.)

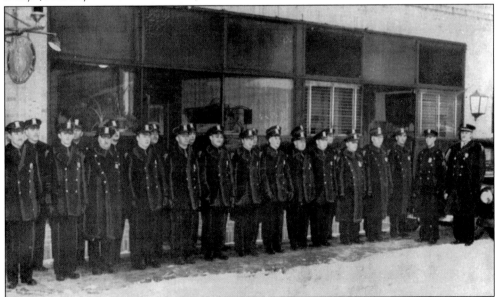

Valley Stream formed their first police department, consisting of one captain and eight officers, upon their incorporation in 1925. On June 10, 1929, the 21 officers of the Valley Stream Police Department merged into the Nassau County Police Department. Shortly afterward they built a new 5th Precinct at 30 West Jamaica Avenue. The building still stands today as a church. (Courtesy of Peter and Beryl Bauer.)

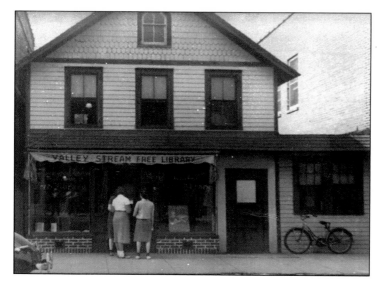

Library services in Valley Stream started in 1932 on the top floor of the building on Rockaway Avenue where PJ Harper's currently sits. In 1935, the library moved to this building at 254 Rockaway Avenue, on the west side between Hawthorne Avenue and the railroad. Here, it was more accessible to people coming in off the street. (Courtesy of the Valley Stream Historical Society.)

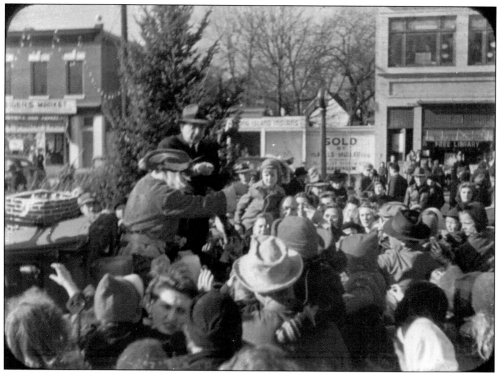

Santa Claus visits Valley Stream in this 1947 Christmas celebration on Rockaway Avenue. Notable in the background is 132 Rockaway Avenue, where the Valley Stream Library moved in 1942. Note Schneider's Market and the (red) sidewalk clock, which has not survived. (Courtesy of Dan King.)

The 1947 Christmas celebration down Rockaway Avenue culminated at the corner of East Mineola Avenue, where a Santa's Village was set up. In the background is the back of the current Bethlehem Assembly of God church on East Fairview Avenue. (Courtesy of Dan King.)

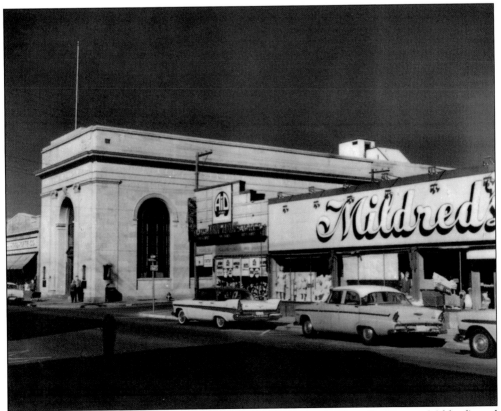

By the 1950s, Rockaway Avenue was becoming a modern suburban downtown. Mildred's and the AiD automotive parts store were located at the southeast corner of Hawthorne Avenue. The Valley Stream National Bank stood opposite it, next to F.W. Woolworth's and Teddy's Ice Cream Parlor. (Courtesy of the Valley Stream Historical Society.)

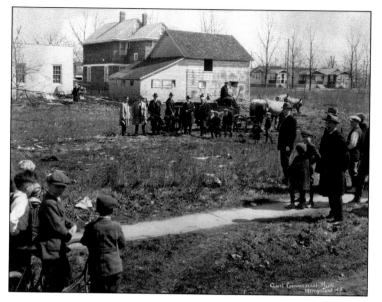

Village officials break ground on the corner of Fairview Avenue and Rockaway Avenue for the Valley Stream Theatre. The theater was a live show house that had a band pit and a stage. Admission cost between 20¢ and 40¢ a ticket. Take note of the Painless Parker advertisement on Fairview Avenue in the background. (Courtesy of the Long Island Studies Archive at Hofstra University.)

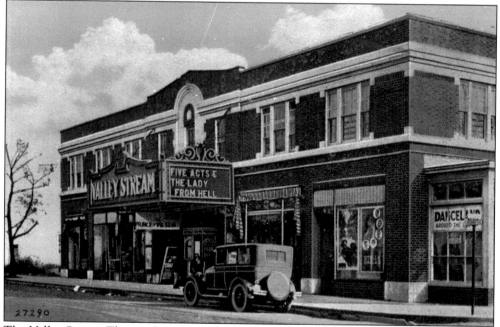

The Valley Stream Theatre, later known as the Rio, was opened on April 24, 1926, as part of Salvatore Calderone of Hempstead's theater chain. This postcard shows the theater in 1926 on the northeast corner of Fairview Avenue and Rockaway Avenue. The Skouras Theatre bought the Rio in 1962, and by the 1980s, the venue no longer showed movies. (Courtesy of Barbara Gribbon.)

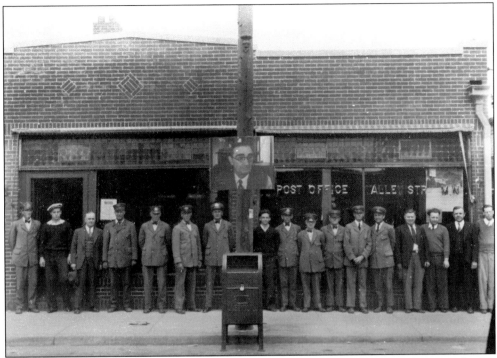

When Robert Pagan brought the first post office to Valley Stream, he set it up in his general store, the Pagan Homestead. The post office itself moved around until it settled at 13 West Jamaica Avenue, as seen in this photograph. This building is now a Baha'i church. (Courtesy of Valley Stream Historical Society.)

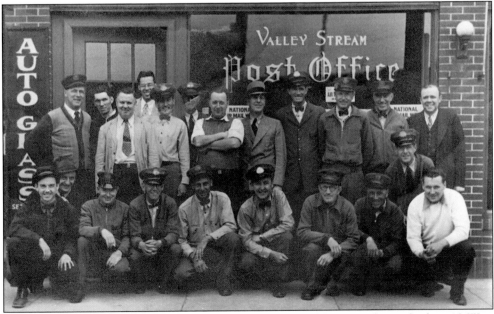

The 22 employees of the Valley Stream Post Office in the 1930s stand outside their 13 West Jamaica Avenue headquarters. After the post office moved to South Franklin Avenue, the building became the home of the Valley Stream Elks. (Courtesy of Fred Lamond.)

The intersection of Rockaway Avenue and Merrick Road has changed greatly over time. Originally, Rockaway Avenue terminated at the Merrick Plank Road, but after Robert Dibble built up the area north of it he continued the road to Wheeler Avenue. This photograph from 1939 shows an empty northwest corner and MacLobe Lumber Yard on the northeast corner. (Courtesy of the Nassau County Police Museum.)

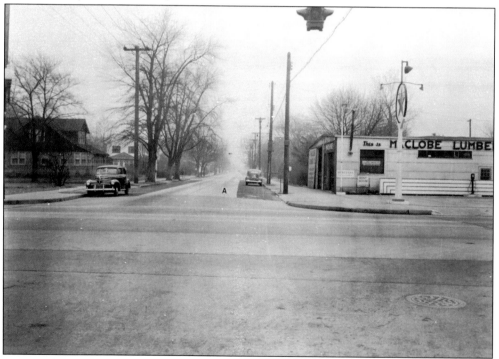

In 1944, the northwest corner of Rockaway Avenue and Merrick Road was still bare. MacLobe continued on the northeast corner, and a Texaco station joined it in front. (Courtesy of the Nassau County Police Museum.)

By 1951, a building had been constructed on the northwest side of the road, housing Victoria Pharmacy, a delicatessen, and an Atlantic & Pacific Tea Company grocery store. The Texaco has changed to a Shell, and MacLobe has renovated its building. Also, the bridge signs are still there. (Courtesy of the Nassau County Police Museum.)

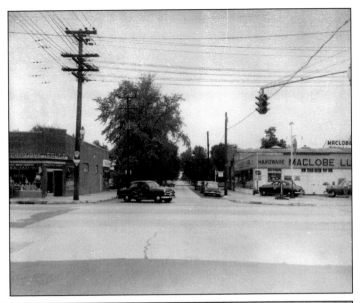

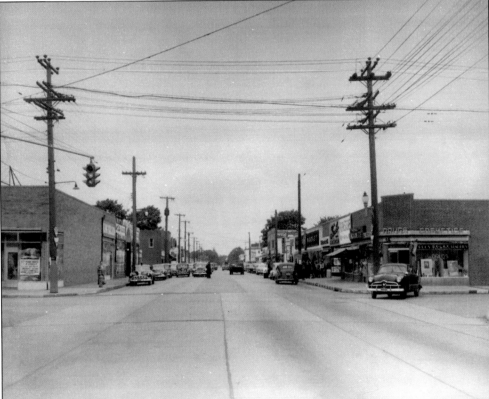

Competing supermarkets face each other in this 1951 shot of Merrick Road looking west at Rockaway Avenue. On the south side of the street is one of the first King Kullens. On the north side is a new A&P. Along with Bohacks and Community Market, these supermarkets would dominate Valley Stream at the beginning of the 20th century. (Courtesy of the Nassau County Police Museum.)

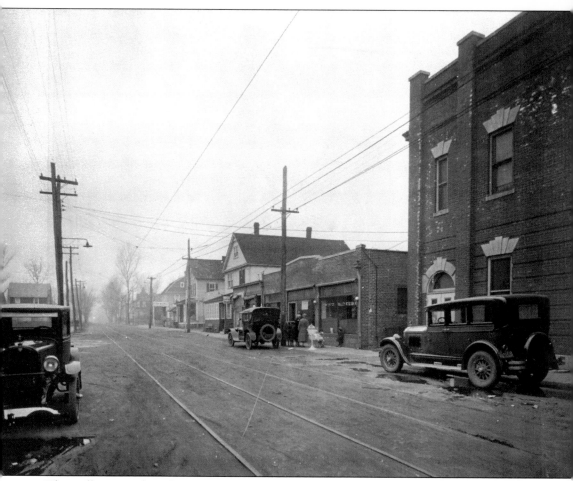

The trolley came down Jamaica Avenue, crossing Rockaway Avenue by Doc Muller's drugstore and moving on to Lynbrook. In this rare picture from the 1920s, one can see the trolley tracks in the dirt road looking west down West Jamaica Avenue. The 5th Precinct on West Jamaica Avenue has not been built yet (it would be right before the house on the left side). On the right sits the old post office and the back of Muller's building. Some old maps refer to Jamaica Avenue by the name of its neighboring street, Valley Stream Boulevard. While that may have been an early name (the current Valley Stream Boulevard was originally New York Avenue), the roadway was bequeathed the name Jamaica Avenue because its trolley went from Freeport to Jamaica, Queens. (Courtesy of the Nassau County Police Museum.)

Three

AROUND TOWN

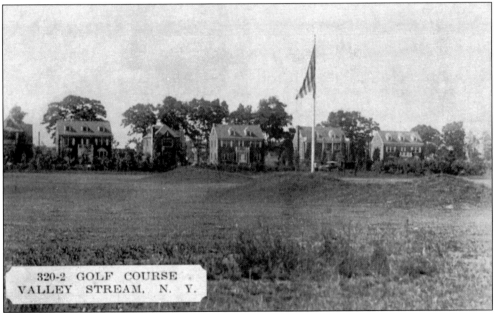

320-2 GOLF COURSE
VALLEY STREAM, N. Y.

Valley Stream in the early 20th century had a golf course on the north side, east of Franklin
Avenue at Dutch Broadway. The golf course barely survived the Southern State Parkway's
construction in 1927 but fell victim to the housing boom soon after World War II. (Courtesy of
Barbara Gribbon.)

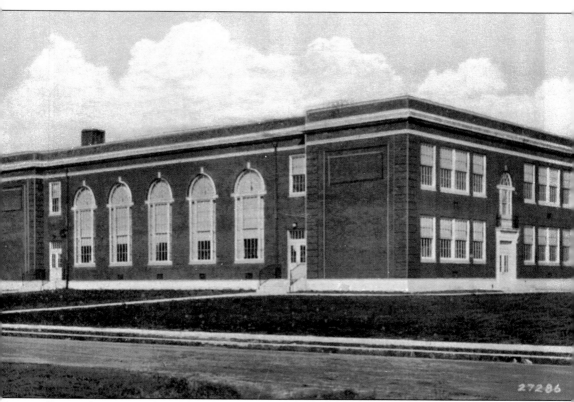

Due to the overcrowding at Brooklyn Avenue School, District 24 opened the Franklin School in 1925 to accommodate the increased population. The school was built on the block surrounded by Franklin Avenue, Hicks Street, West Valley Stream Boulevard, and Jamaica Avenue and was filled with top-of-the-line amenities. In 1973, the Franklin School was renamed for Rev. William F. Donahue but did not last. The school was torn down in 1984 due to dwindling enrollment, and the Valley Park Townhouses are on the site now. (Courtesy of Barbara Gribbon.)

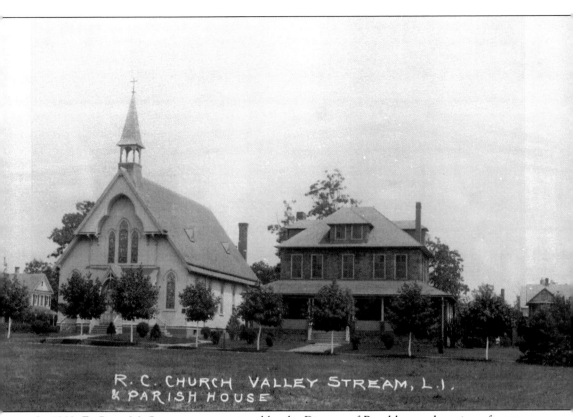

R. C. CHURCH VALLEY STREAM, L. I.
& PARISH HOUSE

In 1902, Fr. Peter McGovern was appointed by the Diocese of Brooklyn as the priest of a new Roman Catholic Parish in Valley Stream called St. Mary's. After temporarily using the Corona Avenue firehouse to celebrate mass, and the Horton House on the southwest corner of West Lincoln Avenue and South Corona Avenue as a rectory, a new Holy Name of Mary church building was opened in December 1903 on the southeast corner of South Grove Street and East New York Avenue (today's Valley Stream Boulevard). A rectory was built on the south side of the church in 1904. To further religious education, the parish opened a school building across the street in April 1939 on the village's former fairgrounds. Over the years, the Catholic population in Valley Stream grew, meriting another Roman Catholic parish in the village. Blessed Sacrament Church opened in the north part of the village in 1950. (Courtesy of Barbara Gribbon.)

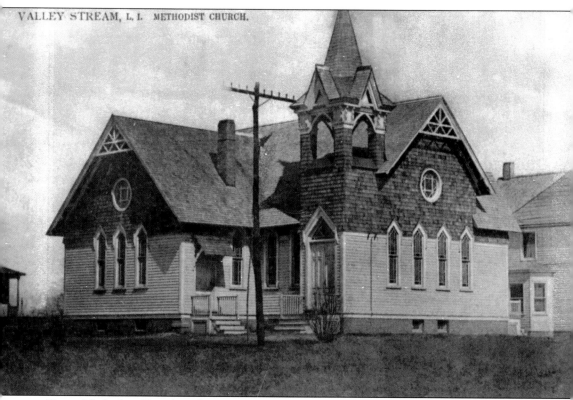

Grace Methodist Church is the same congregation that Ellen Pagan started in her home and continued at the Sinner's Hope Chapel in the 1840s. The congregation moved to the corner of Fairview Avenue and South Franklin Avenue in 1905 and later to its present location on Lincoln Avenue in 1957. (Courtesy of Barbara Gribbon.)

This 1910 building at the northeast corner of Merrick Road and Ocean Avenue still stands to this day, but it is no longer the auto center it was for numerous years. The Ocean Avenue garage was originally owned by Hen Karkick and Bill Jackson but spent the majority of its years owned by Jack Studnick. In the 1990s, it was sold by Studnick's son Michael Studnick and is currently a Dominican deli. (Courtesy of the Valley Stream Historical Society.)

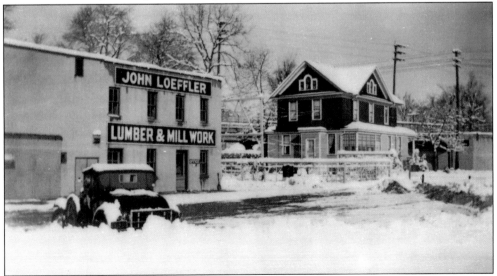

John Loeffer ran a lumberyard on the south side of East Merrick Road, just east of the West Hempstead branch railroad tracks. This photograph from the 1930s also shows Loeffer's Dutch Colonial house. This site has been home to 5-Star Lumber since 1989. (Courtesy of the Valley Stream Historical Society.)

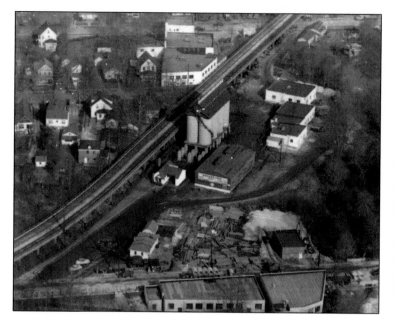

Dickel Incorporated Quality Coal, Coke, and Fuel Oil was located on the north side of East Hawthorne Avenue, just east of the West Hempstead branch railroad tracks. This photograph from 1960 shows the eight-cylinder coal silo that was torn down only a few years later. In 1969, Ray Rizzo took over the yard. (Courtesy of the Valley Stream Historical Society.)

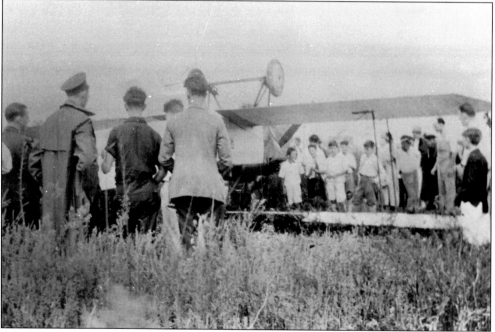

A biplane crashed on a field on the border of Lynbrook and Valley Stream on September 11, 1927, at 12:30 p.m. The field, presumably the William L. Buck farm south of Scranton Avenue and east of Horton Avenue, became a makeshift landing pad for the WACO biplane after it lost its engine during an electrical rain storm. (Courtesy of the Lynbrook Historical Society.)

William L. Buck School was built in 1952 to accommodate the increased population in the village, especially in the Wallendorf Park section. The school, named after the longtime school board member, was built on the Buck farm and became a part of District 24. (Author's collection.)

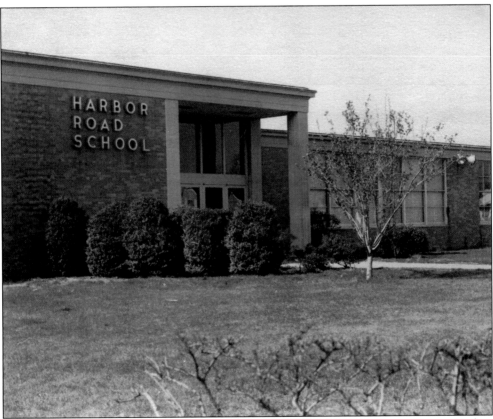

Due to the influx of families moving into the Gibson neighborhood and the former Hungry Harbor, District 24 built a new school in 1954. The Harbor Road School had state-of-the-art facilities and 20 classrooms. It was renamed for Robert W. Carbonaro in 1970. (Author's collection.)

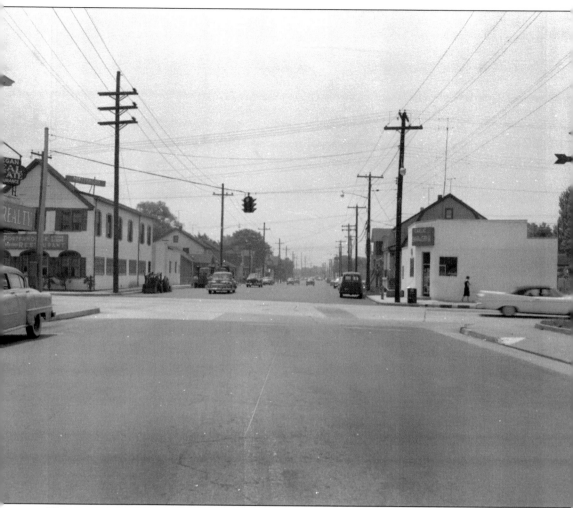

The crossroads of Central Avenue and Merrick Road remained a commercial hub into the 20th century. This shot shows Central Avenue crossing Merrick Road, looking south, on June 3, 1959. On the southeast side of the street is the Porterhouse Restaurant in the old Tom West Hotel. On the northeast corner is the old Fletcher store, currently a real estate office and soon-to-be Rivoli TV. The Sunoco station on the northwest side has replaced Hoffman's and is still there to this day, and the southwest side is the Gaelic Bar and Grill, which would become CC Pub and the Foxy Hutch. The building has been demolished, and the site is currently a parking lot for Enterprise Car Rentals. (Courtesy of the Nassau County Photo Archive.)

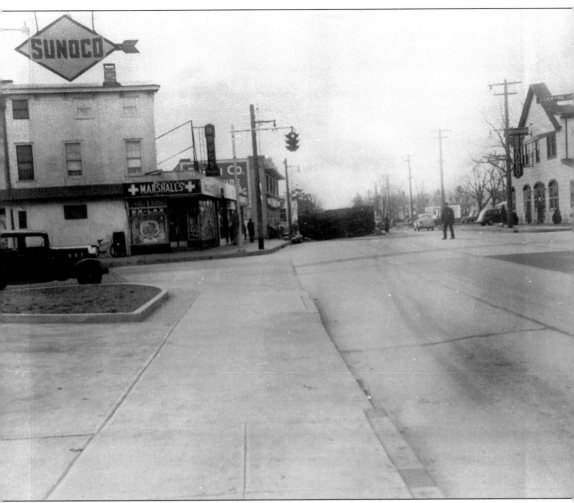

A truck turned over on Merrick Road near its intersection with Central Avenue in this 1947 photograph. The shot, looking eastbound, shows the Porterhouse Restaurant on the southeast side of the street, in the building that was Tom West's hotel. On the northeast side is the old Fletcher Store, which was being used as the base of Marshall's Pharmacy pictured here (years later, Marshall's would move to the southwest corner). A keen eye will also notice the Brookside Apartments in the far back. (Courtesy of the Nassau County Police Museum.)

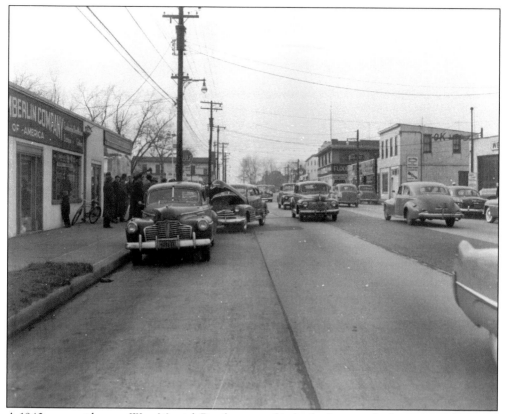

A 1940s car accident on West Merrick Road, captured in both photographs, has attracted a crowd of onlookers. The top photograph, looking west, shows buildings on the north side of Merrick Road that are still there today (though not the same businesses). At the crossroad with Central Avenue in the back, the Porterhouse and Fletcher's Store are both visible in the background. The Chamberlin Company building in the foreground has since been torn down. Looking east, the Brookside Apartments are visible in the background. The future site of the Hills Shopping Center and Belair Theatre is the grassy area on the left side of the photograph. (Both, courtesy of the Nassau County Police Museum.)

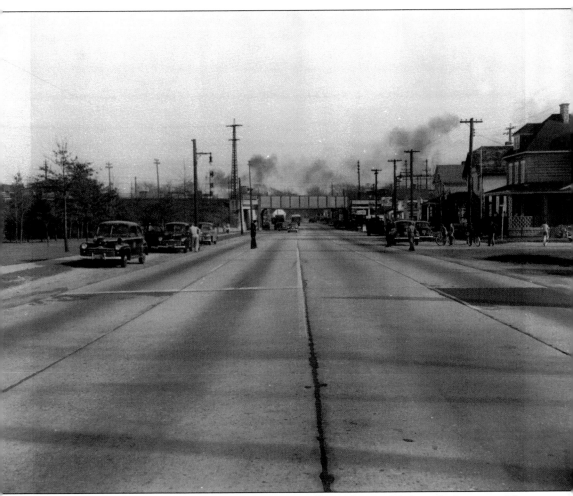

This shot from 1948 shows a police officer directing traffic on Sunrise Highway looking east. The park on the left side would soon become the Sunrise Plaza properties. The Colonials on the right side would be demolished when Sunrise Highway was widened in 1952. Beyond the elevated tracks is the Pitney Hotel on the northwest corner of Sunrise Highway and Rockaway Avenue (also demolished in 1952 when Sunrise Highway was widened); the Coral Inn is on the triangle between Sunrise Highway, Brooklyn Avenue, and Fifth Street (it turned into Legz nightclub in the 1970s and was torn down in 1983); the Air Flex and Dibble Realty building is on the southeast corner of Sunrise Highway and Rockaway Avenue (recently torn down for a condominium complex); and a row of stores, including a druggist, Kelly's Candy Store, and apartments that would be torn down in 1970 for a sit-down Wetson's Restaurant (later a Roy Rogers, now a McDonald's). (Courtesy of the Nassau County Police Museum.)

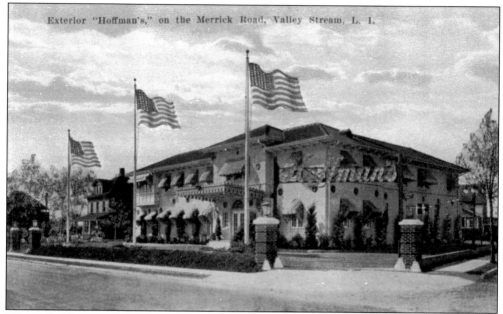

Exterior "Hoffman's," on the Merrick Road, Valley Stream, L. I.

When the Roaring Twenties hit Valley Stream, roadhouses and nightclubs started popping up all along West Merrick Road. Hoffman's, located on the northwest corner of West Merrick Road and North Central Avenue was one of the most famous. It was eventually taken over by a Mae West look-alike named Texas Guinan who greeted all her customers with a sassy "Hello, Sucker." (Author's collection.)

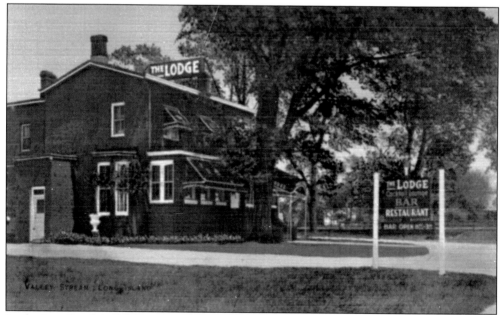

In the Jazz Age, Merrick Road was full of nightclubs and hotels, where some of the era's greats played. In addition to Hoffman's, Club Esquire, the Pavillon Royal, the Bird Cage, and the Murphy House, there was The Lodge, at 825 West Merrick Road near the Queens border. Today, the building is still standing and since 1965 has been the easternmost part of The Knights of Columbus St. Therese's Hall. (Courtesy of Barbara Gribbon.)

Hoffman's, like many of the Valley Stream nightclubs, prospered during Prohibition. When actress and nightclub owner Texas Guinan took over the club in 1929 (renaming it Texas Guinan's Show Palace and later La Casa Guinan in 1932) she continued with the activity her Manhattan speakeasies were known for. In Manhattan, she had been arrested numerous times for serving alcohol and was well known for running a brothel out of her 300 Club. She played host to many well-off patrons, whom she referred to as her "butter and egg men," and was associates with Al Capone, Dutch Schultz, and Hymie Weiss. In the grandest of ironies, she died in 1933, one month before Prohibition was repealed. (Courtesy of Barbara Gribbon.)

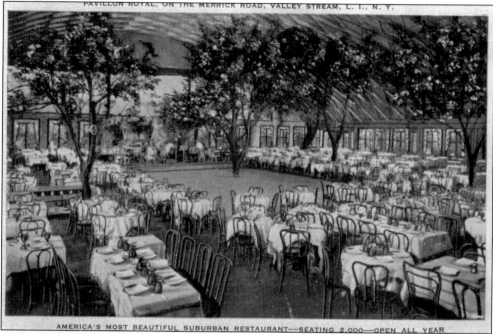

AMERICA'S MOST BEAUTIFUL SUBURBAN RESTAURANT—SEATING 2,000—OPEN ALL YEAR

The other major roadhouse on West Merrick Road in the 1920s was the Pavillon Royal, which sat on the southern side of West Merrick Road between South Montague Street and South Terrace Avenue. Originally the Irma Park Hotel, the roadhouse was a frequent destination of bicyclists, who made use of the dirt tracks in front of the building. The interior, seen in the above postcard, featured acts like Rudy Vallee, Guy Lombardo, and Paul Whiteman. After it closed, a roller rink and then the Pavillon Lanes Bowling Alley took up its eastern side, while the Park Inn Ford took its west. Later owner Joseph Gathard closed down the Pavillon Lanes Bowling Alley and made the building an office. (Both, author's collection.)

The above photograph shows a dirt road looking south along North Montague Street, crossing West Merrick Road. On the left one can see the back of the West End Tavern, and on the opposite corner is the former site of the Pavillon Royal. By 1945, the Pavillon Royal was gone, and the building was replaced by a one-story structure that would later become the Pavillon Lanes Bowling Alley. By the mid-1960s, owner Joe Gathard turned it into an office building. The photograph below shows the reverse site, giving a clearer picture of the West End Tavern and some houses behind it. Even in 1945, this part of Valley Stream was spread out. (Both, courtesy of the Nassau County Police Museum.)

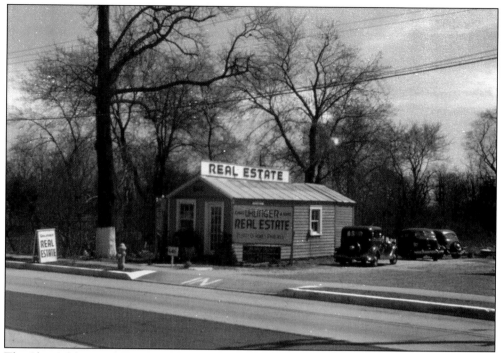

The Chris Uhlinger and Sons Real Estate office was opened in 1946, a few blocks west of Clearstream Avenue on the south side of Merrick Road at 646. This photograph, from 1947, is a great example of the real estate boom in Valley Stream in the postwar years. Today, Bruce Plumbing sits on the site. To the east of the real estate office was the Gulf Station shown in the photograph below. The site is currently Bruce Plumbing. (Both, courtesy of Dan King.)

In 1963, Fr. Peter McGovern, the man who brought Holy Name of Mary through its birth, died. Fr. Joseph Butler took over as the priest and made it a priority to build a new church. In 1956, ground was broken on a new church building that would incorporate a portion of the original church in its construction. The basic frame from the old church is still present in the South Grove Street entrance, as the new church was bricked around it. A south wing was added that faces East Jamaica Street, and the old rectory was removed and the Blessed Mother Shrine stands in its place. The first mass was held at the new church on December 22, 1957. (Courtesy of Dan King.)

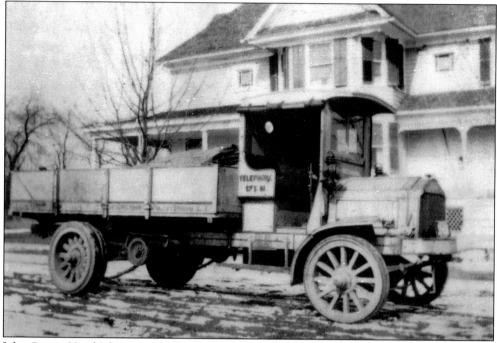

John Corner Hendrickson started Hendrickson Brothers Construction in 1903. They incorporated as a business in 1922 and had an office on Central Avenue until the 1990s. The business was passed down to succeeding generations, including Mayor Arthur J. Hendrickson and his son Milton Hendrickson. The above photograph shows one of their trucks going about its work. They also owned a sandpit on North Corona Avenue near the Southern State Parkway. The photograph below shows the pit around 1943. The land later became the parking lot for Franklin General Hospital, bordering Blakeman Avenue (so named for Assemblyman Robert Blakeman, who helped in the purchase of the land). (Above, courtesy of the Valley Stream Historical Society; below, courtesy of the Nassau County Police Museum.)

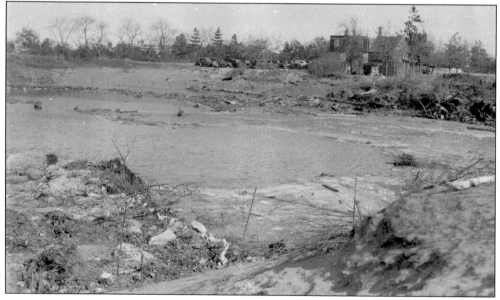

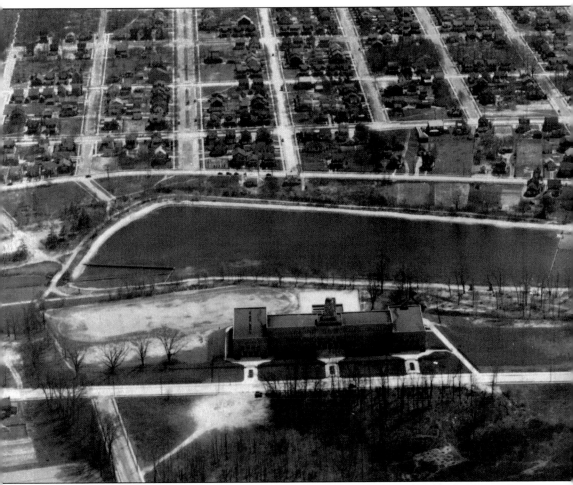

This overhead photograph of Central High School shows how empty much of the land was when it was built in 1929. Before this building was constructed, high school students had to travel to Lynbrook to get an education. The Brooklyn Avenue District 24 School was used to educate some students at a high school level in 1923 but soon resumed instructing solely at the elementary level. The Central High School District was formed in 1925, and the District 13 School became the official high school for the district, until Central High School was built. The first graduating class was in 1927. (Courtesy of the Valley Stream Historical Society.)

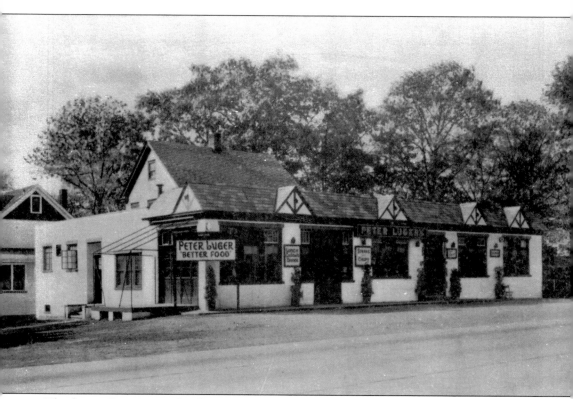

The famous Peter Luger of Williamsburg, Brooklyn, also ran a restaurant in Valley Stream. This photograph shows the Valley Stream restaurant as it appeared in the 1930s on the southwest corner of Sunrise Highway and Brookside Avenue. The restaurant operated for many years, until Luger's death in 1941 at age 74. He left his estate and restaurants to his three children, including Arline Gaucher, who lived at 71 Bismark Avenue. Peter Luger's Valley Stream closed shortly after and became Edouard's Restaurant (later Edward's). The building, along with its neighbor The Gateway Inn/The Publick House, across Seventh Street, was eventually demolished by Nathan Serota for his massive office structure in the 1980s. (Courtesy of Barbara Gribbon.)

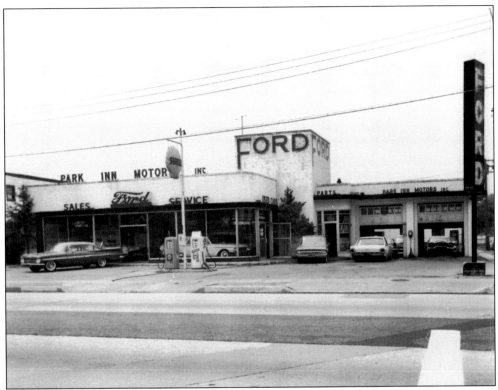

One of the many car dealerships on the West Merrick Road stretch of Valley Stream is Park Inn Ford. Started in 1920, Park Inn Ford is situated on the southeast corner of West Merrick Road and South Terrace Avenue. The building structure has not changed significantly since this photograph was taken in 1961. In the 1980s, the owners incorporated Acura cars into the dealership, and today, that is its focus. The Shell gasoline pumps, neon sign, and letters attached to building are all gone. (Author's collection.)

VALLEY STREAM PARK INN

Carl Hoppl opened his first hot dog stand in 1933, across from the State Park (currently Hendrickson Park) on West Merrick Road. Over the years, Hoppl purchased and ran many restaurants all over Long Island and in 1966 renovated his Valley Stream stand into a restaurant called the Valley Stream Park Inn. Hoppl died in 1979, and eventually his restaurant closed down. This menu is from the Valley Stream Park Inn right before its closing. The site is currently the Mandee's shopping center. (Author's collection.)

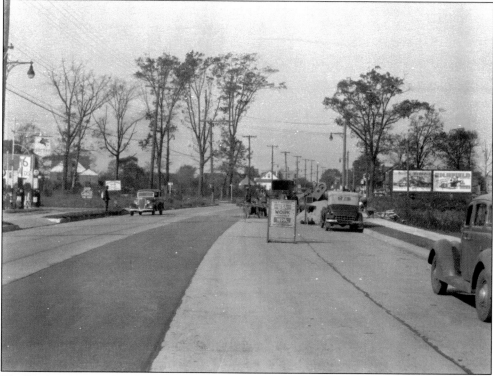

The Works Progress Administration paves West Merrick Road looking westbound around Arlington Avenue in this 1934 photograph. Take note of the SOCONY (Standard Oil Company of New York, the original name of Mobil Gas) gas station on the left side, the Texaco gas station hidden behind the tree on the right side, and the old billboards for Raynor Motors on East Merrick Road and Richfield Gasoline. The photograph below captures the road a short time later. There is more development, and the billboards have changed to advertisements for Ballantine Beer and Swan Soap. (Both, courtesy of the Nassau County Police Museum.)

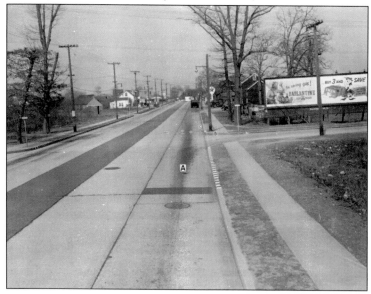

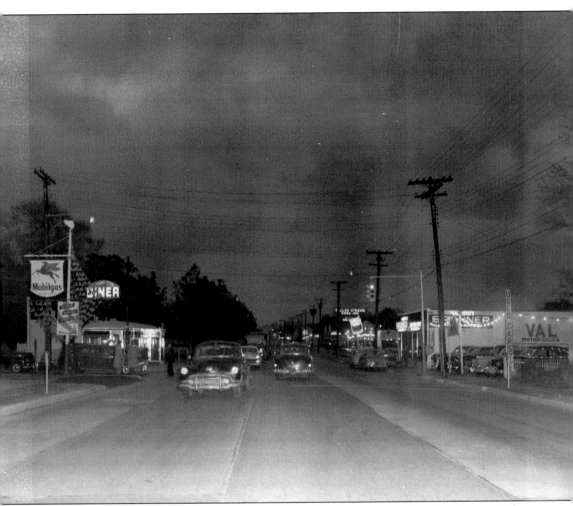

This 1954 nighttime shot shows East Merrick Road looking east on Fletcher Avenue. The surroundings have changed in later years. On the northern side of the road, a bank replaced the Rainbow Diner in 1973. A Dime Savings Bank replaced the Mobil gas station in 1974. On the south side, Tom Tom Used Cars, Val Motor Sales, and the Brenner Real Estate building are now the Rite Aid shopping center, which was constructed in 1979 as a Genovese shopping center. Carl Hoppl's Valley Stream Park Inn is now the Mandee's shopping center. (Courtesy of the Nassau County Police Museum.)

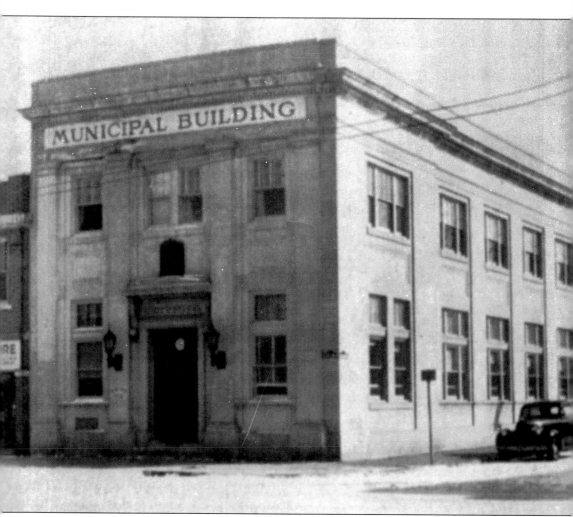

Valley Stream moved their village hall into this building on the northeast corner of Rockaway Avenue and Jamaica Avenue on October 15, 1936, due to space issues in their previous headquarters. The Municipal Building was originally constructed in 1926 as the Bank of Valley Stream. When the village moved their offices to the Village Green in 1955, they sold off the Municipal Building, and it eventually became a bank once more. Recently, the village has bought the building back and is using it for their code enforcement and court. (Courtesy of Peter and Beryl Bauer.)

Four

IN THE COMMUNITY

Three turn-of-the-20th-century houses on Brooklyn Avenue between Fourth Street and Fifth Street are all still standing to this day. The house at 34 Brooklyn Avenue, on the extreme left side, was built in 1903. It is an American Colonial with a side porch. 30 Brooklyn Avenue, in the center, is a Victorian Colonial built in 1903. The porch has been enclosed since the photograph was taken. The house at 28 Brooklyn Avenue, at right, was built in 1922. It is a Dutch Colonial with gambrel roof. This porch has also since been enclosed. (Author's collection.)

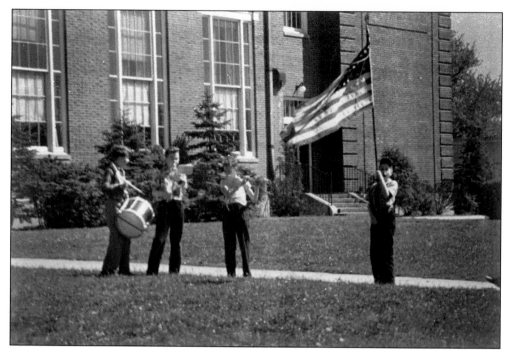

Above, three students at Valley Stream Central High School raise an American flag and mimic Archibald Willard's famous painting, *The Spirit of '76*, at a celebration in 1945. Below, snow covers Valley Stream State Park (currently Arthur J. Hendrickson Park) as the silhouette of Valley Stream Central High School towers in the background. (Both, courtesy of Dan King.)

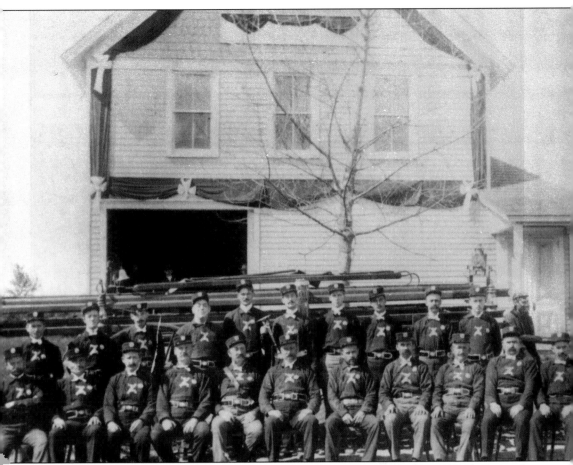

Valley Stream's first fire company, Nassau Hook & Ladder, was organized in 1898 after several fires in the village created the need for a fire department. In 1900, a lot on South Corona Avenue between Hawthorne Avenue and Jamaica Avenue was purchased, and a new firehouse was opened on the site in 1901. Pictured here is the first fire department in Valley Stream in front of the newly built Corona Avenue firehouse and the department's hand-drawn ladder and bucket truck. (Courtesy of the Valley Stream Historical Society.)

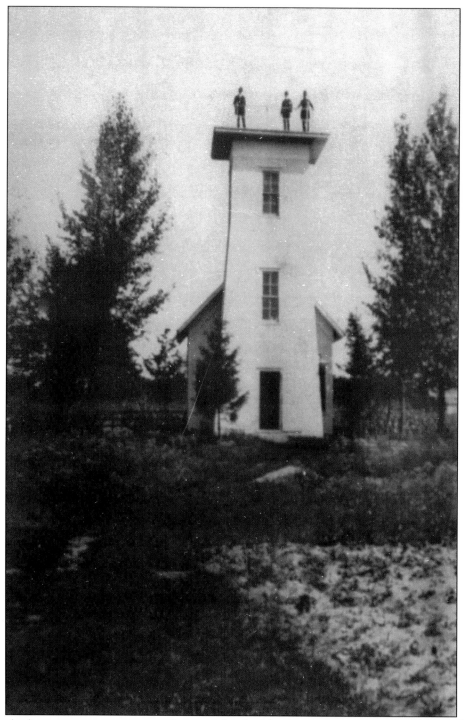

Fire lookout towers were common in areas that had large amounts of woodland like Valley Stream. This specific fire tower, seen in the 1890s, sat on the highland towards the rear of the Pagan Homestead on Hendrickson Avenue. Eventually, it met the same fate of many fire towers; it burned down in 1931. (Courtesy of the Valley Stream Historical Society.)

The Pagan Homestead had been a residence for most of its existence and, as expected, has been altered a few times over the years. Pictured here in 1941, the home was occupied by the Fairchild family, the last private residents before the building became offices. (Courtesy of the Valley Stream Historical Society.)

A very empty Hendrickson Avenue and the corner of Henry Street and Fletcher Avenue can be seen looking westward in 1941. The land to the left, the open field with the Mills-Miller Real Estate Company sign, was part of the Fletcher property and would become Memorial High School in 1952. On the right of the street, the house with a sign for Stately Oaks Model home was Henry Hendrickson's birthplace and the Hendrickson homestead. It would be torn down for development. (Courtesy of the Nassau County Police Museum.)

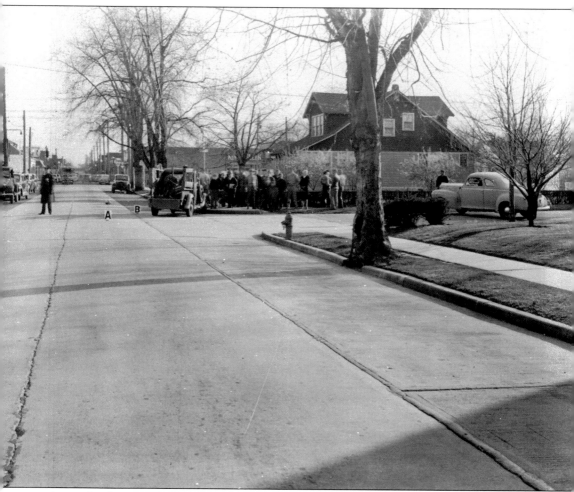

A crowd gathers at a car accident on the corner of Maple Street and Rockaway Parkway. In the early 1920s, Robert Dibble and Arthur McDermott purchased and developed the area of Valley Stream north of Merrick Road along Rockaway Parkway, building up houses in the area and extending Rockaway Avenue (which originally ended at Merrick Road) up to Wheeler Avenue and then on to Corona Avenue. In this late-1930s photograph, looking south down Rockaway Avenue, one can see the elevated railroad tracks, as well as notable village landmarks along the way, including the Tydol gas pumps at Kiki's Station, the Valley Stream Auto Parks Company, and MacLobe's Lumber Yard. Also of note is the King Kullen store on Merrick Road, one of the first on Long Island. (Courtesy of the Nassau County Police Museum.)

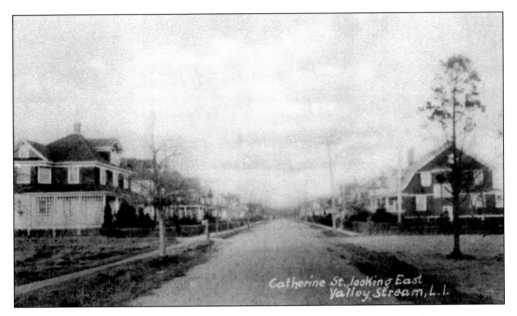

Catherine Street and Miriam Street were two of the streets developed by Augustus Abrams in 1903, alongside Sylvan Place and Forest Avenue. The development is adjacent to the neighborhood that was divided from the Horton Farm in 1895, known as Wallendorf Park. Woodlawn Avenue, Bismark Avenue, and Horton Avenue make up the majority of the Wallendorf Park neighborhood, and houses in the area date as far back as the mid-1890s. In the above postcard, the old Colonials on Catherine Street can be seen from a vantage point on Rockaway Avenue. Below, Forest Avenue at the end of Miriam Street is visible. Just off the right side of the postcard would be Zirkel's Funeral Home, which was demolished in 1967. Behind the photographer would have been Community Market. (Both, courtesy of Barbara Gribbon.)

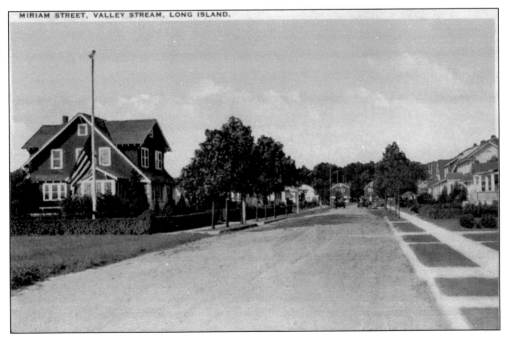

The South Grove apartments were built in 1929 across from Holy Name of Mary church on the southeast corner of South Grove Street and East Jamaica Avenue. This postcard, from the early 1930s, names them on the back as the Louise Court and James Court apartments. (Courtesy of Barbara Gribbon.)

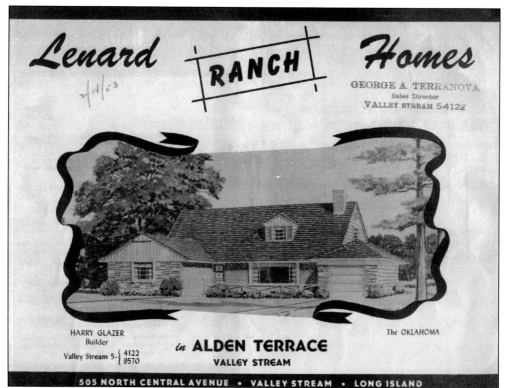

Lenard RANCH *Homes*

GEORGE A. TERRANOVA
Sales Director
VALLEY STREAM 5-4122

HARRY GLAZER
Builder

Valley Stream 5-{ 4122 9570

in ALDEN TERRACE
VALLEY STREAM

The OKLAHOMA

505 NORTH CENTRAL AVENUE • VALLEY STREAM • LONG ISLAND

The Alden Terrace neighborhood of Valley Stream is made up of the former Foster's Meadow area west of North Central Avenue and south of the Southern State Parkway. The area is technically part of North Valley Stream under the jurisdiction of the Town of Hempstead. This Leonard Ranch Homes brochure from 1953 is trying to attract people into this fresh area with new suburban homes. (Courtesy of the Long Island Studies Institute at Hofstra University.)

Pictured here is John W. Gathard as a boy in the early part of the 20th century. Gathard would go on to become a village trustee and the village clerk in the 1970s. His son Joseph Gathard would become a village trustee in the 1980s. (Courtesy of Joe Gathard.)

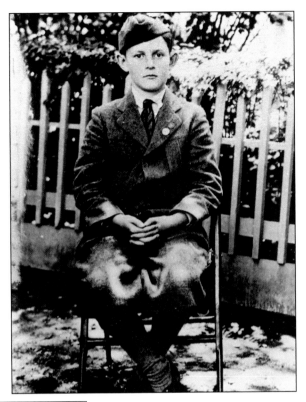

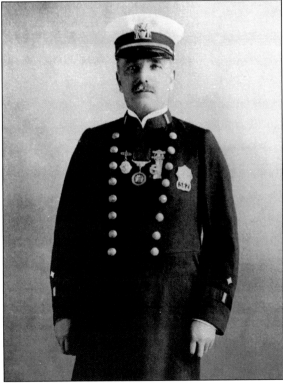

James M. Wheelwright was a former New York City police officer, but when Valley Stream formed their own police force, he joined and became its chief. In 1929, the Valley Stream Police Department merged into the Nassau County Police Department, and Wheelwright became an inspector with the department. (Courtesy of Joe Gathard.)

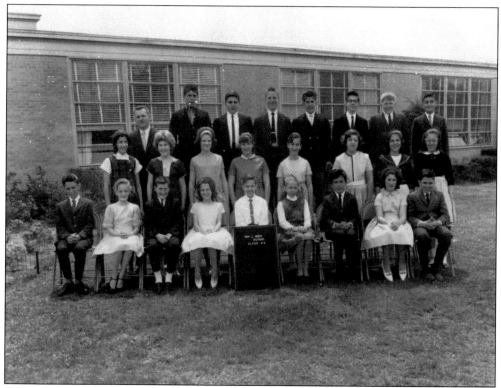

Here the William L. Buck Elementary School's graduating class of 1963 poses for their class picture. From left to right are (first row) Glenn Strack, Carol Brumer, Danny Demao, Sharon Faithful, Joseph Mirro, Chris Stacy, Pete Panzarino, Patty Shienman, and Stanly Marshall; (second row) Kathy Dankna, Gail Gorden, Emily Gruffman, Sandy Cohen, Helene Justman, Judy Forkos, Cornelia Mitchel, and Barbara Moskowitz; (third row) Robert Kregal (teacher), Lester Zinger, William F. Florio, Robert Kagan, David Hernandez, Danny Bilick, Hans Luca, and Joseph Fauty. (Author's collection.)

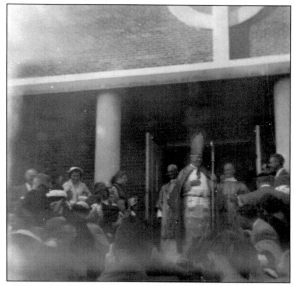

Bishop Walter Kellenberg of the Diocese of Rockville Centre stands at the entrance of Holy Name of Mary church on Jamaica Avenue in June 1958. Kellenberg was the first bishop of the Diocese of Rockville Centre after it broke away from the Diocese of Brooklyn. (Author's collection.)

Bartolomeo Florio, Michael R. Florio, and William F. Florio stand on the stoop of their 10 Delmonico Place house in the mid-1950s. William Florio would later go on to be the chairman of the Board of Zoning Appeals for Valley Stream. (Author's collection.)

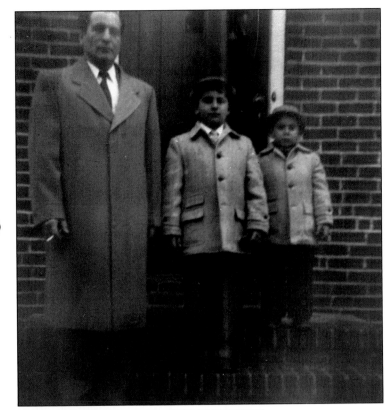

Happy children attend a 1950s birthday party for William F. Florio at his parent's house at 10 Delmonico Place. Pictured here are, from left to right, an unidentified child, Michael Lafferty, Michael A. Florio, Michael R. Florio, Andrew Tong, Concette Grillo, Henry Grillo, Robert Emery, Patricia Wade, and Julie Florio. (Author's collection.)

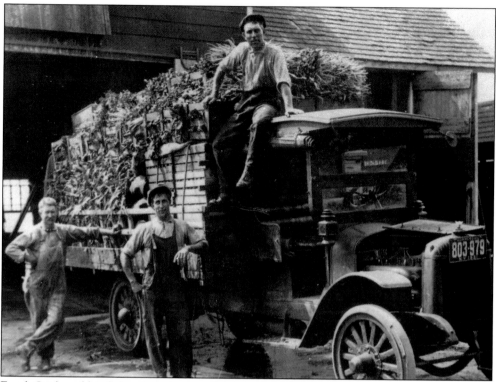

Frank Stick and his father, Joseph, owned a farm on Central Avenue north of Merrick Road at Sapir Street. Pictured here are Frank Stick and his son with their truck. (Courtesy of the Valley Stream Historical Society.)

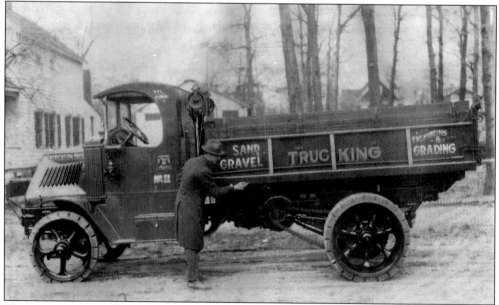

The Hendrickson family was very influential in Valley Stream, and their firm executed construction projects throughout Long Island. This photograph shows one of their trucks. (Courtesy of the Valley Stream Historical Society.)

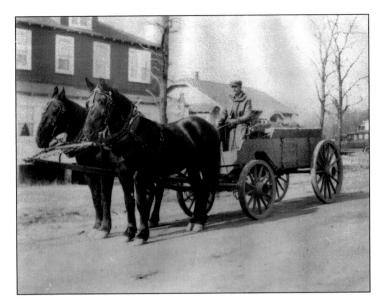

George Wright of Hendrickson Brothers Construction rides down the street in a horse-pulled wagon in this 1927 photograph. (Courtesy of the Valley Stream Historical Society.)

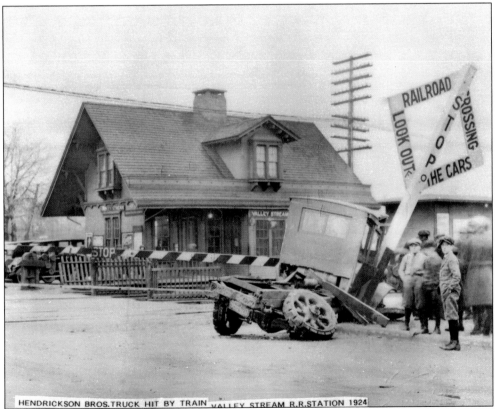

HENDRICKSON BROS. TRUCK HIT BY TRAIN VALLEY STREAM R.R. STATION 1924

When the railroad was at grade level, it was possible for a truck to be hit. The first train accident happened soon after the railroad came through Valley Stream, and accidents would occur sporadically after that until the tracks were elevated. Here, the train has hit a Hendrickson Brothers truck in 1924 at a crossing. (Courtesy of the Valley Stream Historical Society.)

The Village of Valley Stream held part of its 1947 Christmas celebrations at Fireman's Memorial Field on Emerson Place, where Santa Claus would parachute in from a plane to the joy of all the children. The land that became Fireman's Memorial Field was originally the Salvany Langdon farm and was purchased by the Fireman's Athletic Association in the early 1920s. In 1941, the Village of Valley Stream bought the park from the Fireman's Athletic Association for $8,500. Over the years, the field has been the home to the Valley Stream Red Riders football team and the Valley Stream Green Hornets. (Both, courtesy of Dan King.)

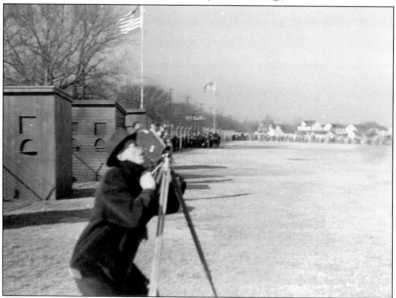

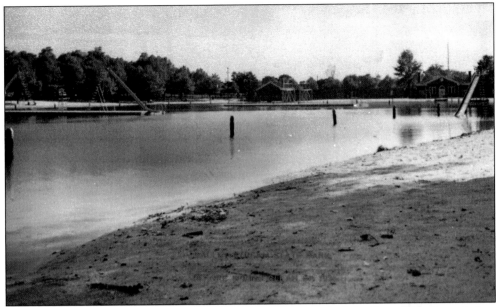

Cornell's Pond in the Valley Stream State Park, under control of the State Park Commission, opened to bathers for just 10¢ back in 1929. Inexpensive even then, people came from all around to sunbathe and swim at the park. Soon, the area became overcrowded and unsanitary, and local residents asked the state to discontinue the service. This image from 1935 shows a much quieter day. (Courtesy of the Valley Stream Historical Society.)

In 1958, the Village of Valley Stream acquired the southern portion of the state park, from Hendrickson Avenue down to Merrick Road, for $103,000. In 1960, they opened a swimming pool there and dredged the lake a few years later to make room for sports facilities. In 1966, the park was renamed for Mayor Arthur J. Hendrickson. (Courtesy of the Valley Stream Historical Society.)

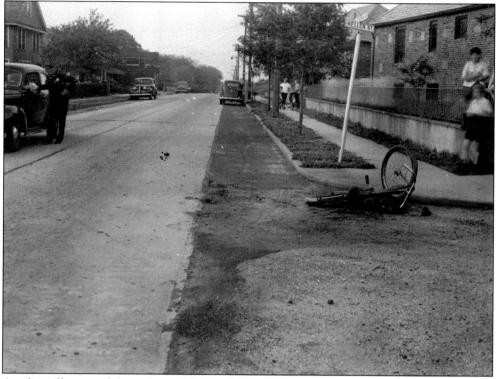

A police officer stands by at the site of a bicycle accident on the corner of Keller Street and North Corona Avenue in June 1945. (Courtesy of Nassau County Police Museum.)

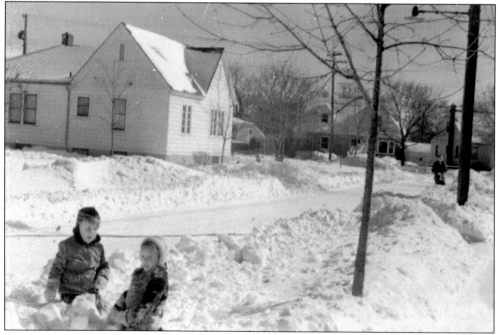

For children, snow days are mostly appreciated because of school cancellation. Here, two children play in the snow in the northern part of the village in the late 1940s. (Courtesy of Dan King.)

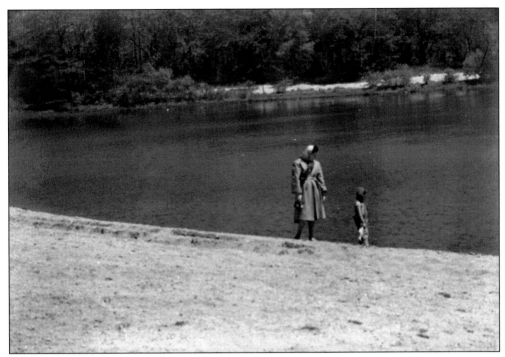

After the New York State Parks commissioner stopped allowing people to bathe and swim at the Valley Stream State Park, Valley Stream residents stopped avoiding it. Here, a mother and child stand by the peaceful lake no longer full of swimmers at Valley Stream State Park. (Courtesy of Dan King.)

The west side of Valley Stream was beginning to be developed in the early 1950s during the real estate boom. This 1953 advertisement is promoting new wide-lined Cape houses in a development in the Arlington Avenue neighborhood north of West Merrick Road. Belpark Realty of Elmont refers to the area as Lynne Terrace, but older maps list the neighborhood as Ormonde Park. (Courtesy of the Long Island Studies Institute at Hofstra University.)

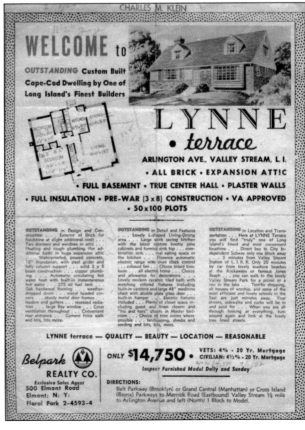

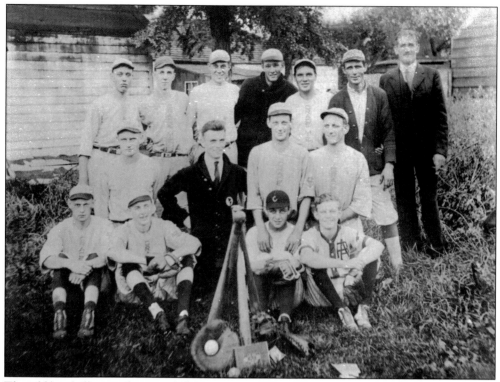

This old baseball team photograph features a young Henry Hendrickson (third row, center, black jacket) before he became the mayor of Valley Stream. Hendrickson was known as a formidable baseball player and was even offered a spot on a New York Yankees minor league team. It is no surprise he is on this team put together by Grace Methodist Church. Another Valley Stream mayor, Arthur J. Hendrickson, was a huge benefactor of the Methodist church. (Courtesy of Peter and Beryl Bauer.)

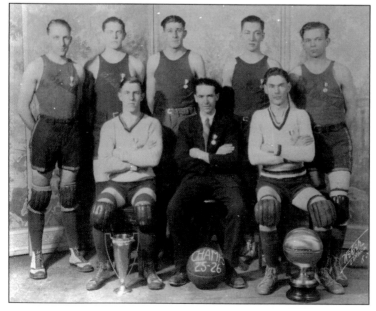

Henry Hendrickson was quite the athlete. He played for the Long Island Separates basketball team and posed for this 1925–1926 championship team photograph. Hendrickson stands in the second row, center in this photograph. (Courtesy of Peter and Beryl Bauer.)

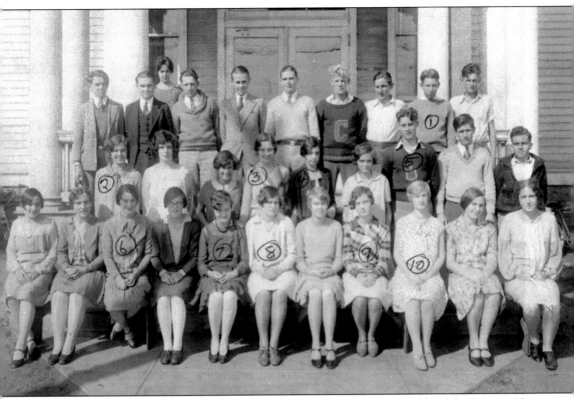

The graduating class of Valley Stream High School in 1929 is posing outside of the District 13 School on the corner of Wheeler Avenue and Corona Avenue that acted as the high school before Valley Stream Central was built. Pictured here are, from left to right, (first row) two unidentified students, Madeline Kappauf, unidentified, Ethel Hume, Rita Loew Weissman, unidentified, Beryl Barker, Alfreda Cole, and two unidentified students; (second row) Caroline Raeder Young, two unidentified students, Catherine Clare Keller, Iris Muller Bock, unidentified, Howard Ruehl, and two unidentified students; (third row) seven unidentified students, Arnold Kemp, and unidentified; (fourth row) unidentified teacher. (Courtesy of Pete and Beryl Bauer.)

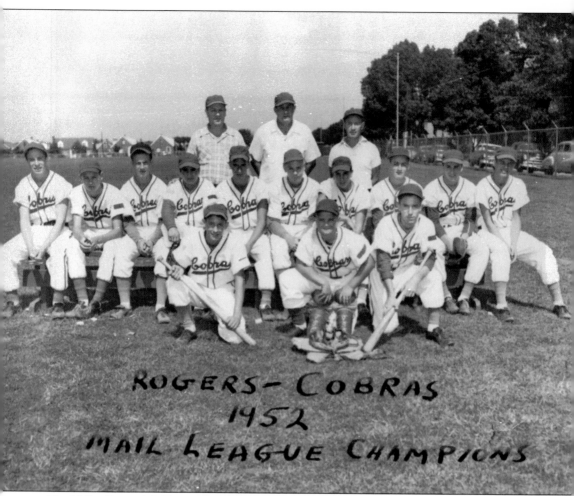

The Valley Stream Mail League baseball was started in May 1943 as an intramural league sponsored by the *Valley Stream Mail* and the *Gibson Herald*. This 1952 photograph shows that year's Mail League Champions, the Cobras, home at Fireman's Memorial Field. Mail League basketball was added in 1966. (Courtesy of Peter and Beryl Bauer.)

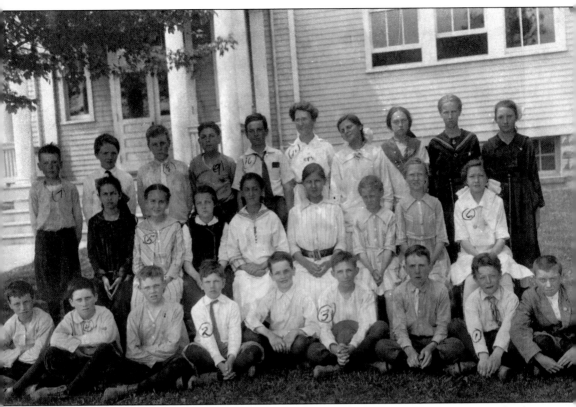

This photograph shows the class picture of the graduating class of District 13 Elementary School in the early 1920s. This was taken before the clapboard school was transformed into Valley Stream's first Central High School. Pictured from left to right are (first row) three unidentified, Walter Wolouch, unidentified, Carl F. Kappauf, and three unidentified; (second row) unidentified, Mildred Combs, five unidentified students, and Viola Hendrickson Fowler; (third row) Herbert Mott, two unidentified students, Elmer Hendrickson, Ed McCarey, a Miss Purdy (teacher), and four unidentified students. (Courtesy of Peter and Beryl Bauer.)

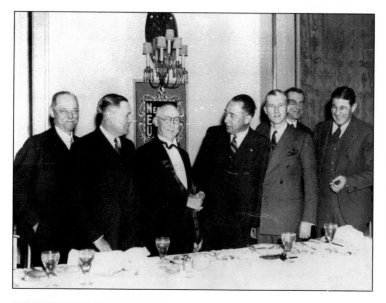

Three Valley Stream mayors pose together in this photograph. At a dinner ostensibly honoring Mayor Henry Waldinger, mayors Louis Hicks and Henry Hendrickson also stand among the dignitaries. Waldinger stands at the center in a tuxedo. (Courtesy of Peter and Beryl Bauer.)

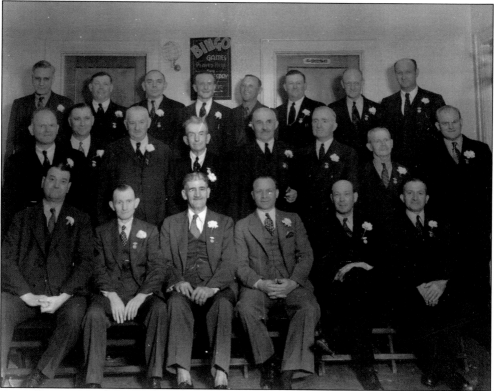

Over the years, Valley Stream became home to many organizations. The American Legion set up on Roosevelt Avenue and the Veterans of Foreign Wars on East Merrick Road. The Knights of Columbus had two locations, one on West Merrick Road and one on Rockaway Avenue and Lincoln Avenue. The Elks were located on West Jamaica Avenue, and the Masons took over the old police station on West Jamaica Avenue. Most of them offered bingo. (Courtesy of Peter and Beryl Bauer.)

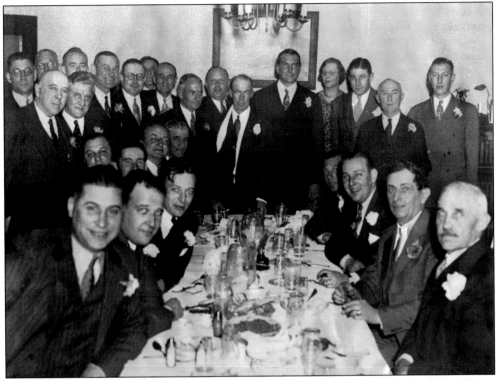

Valley Stream politics has mostly shifted toward Republican views. Most mayors, including Henry Hendrickson, Arthur Hendrickson, Dominick Minerva, Henry Waldinger, Tom Ward, Ralph Grecco, John DeGrace, James Darcy, Edward Cahill, Edwin Fare, and others were Republicans. Many of the village's politicians, however, affiliate themselves with a local party such as the Civic Pride Party, the Integrity Party, the Citizen Party, or the Unity Party. (Courtesy of Peter and Beryl Bauer.)

The year 1903 saw the birth of Henry Hendrickson at the Hendrickson homestead on the northwest corner of Henry Street and Hendrickson Avenue. His life of public service began in 1930 when he was elected constable of the Town of Hempstead. He followed that by being elected Nassau County sheriff in 1935 and an appointment as marshal in the second district court in 1938. In 1941, he was elected mayor of Valley Stream and would be reelected twice. (Courtesy of Peter and Beryl Bauer.)

Over the course of its existence, the village of Valley Stream has had numerous fires. Some have devastated the community such as the Bergman's Bakery Fire in 1898, which prompted the village to establish a fire department. Over the years, fires have brought down Hoffman's in 1926; the Pavillon Royal in 1942; the Grace Methodist Church in 1954; the Flagship Diner (currently Concord Diner) in 1964; Carl Hoppl's Park Inn in 1966; MacLobe Lumber Yard in 1968; the Cochran Place Firehouse in 1968; fire headquarters in 1968; the Valley Stream Post Office in 1970; the American Legion in 1970; the Brooklyn Avenue Firehouse in 1971; and Barry's I Love My Carpet in 1996. (Both, courtesy of Dan King.)

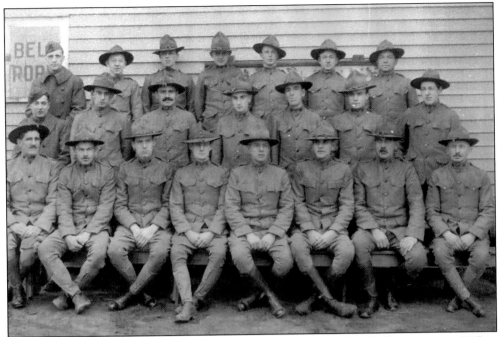

Company B (above) and Company A (below) were both stationed in Valley Stream in 1917 in preparation for the United States' entrance into World War I. The draft was active during the Great War, and many residents of Valley Stream went to fight for their country. The names of the soldiers in these photographs have been lost to time. (Both, courtesy of Leo Bock and the Lynbrook Village Historical Collection.)

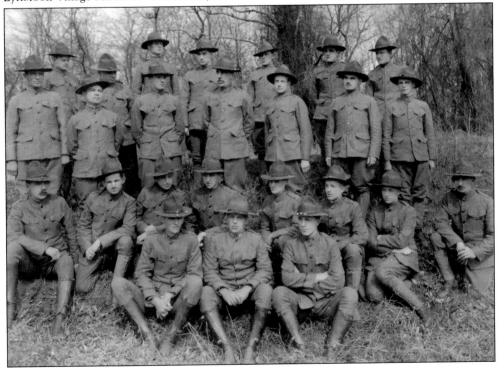

Fletcher Avenue ran through the property of the Fletcher heirs north of West Merrick Road and south of Hendrickson Avenue. The road does not appear on maps prior to the late 1920s, except as a dirt road a few yards off Merrick Road and the Henry Street section north of Hendrickson Avenue (Henry Street is one of the oldest roads in the village). This photograph was taken after Fletcher Avenue was paved, looking north at Lake Drive. Off to the far left in this image is the property that would soon be home to Memorial Junior High School. (Courtesy of the Nassau County Police Museum.)

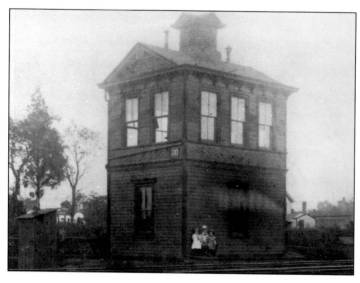

On June 28, 1933, the Long Island Rail Road built a new tower at Valley Stream to assist the multiple branches and rail traffic at the growing station. The tower, named VA Tower, was placed at Franklin Avenue, right before the Far Rockaway branch breaks off. Towers are used to simplify interlocking and prevent trains from going on the wrong tracks. (Courtesy of the Valley Stream Historical Society.)

Five

GIBSON

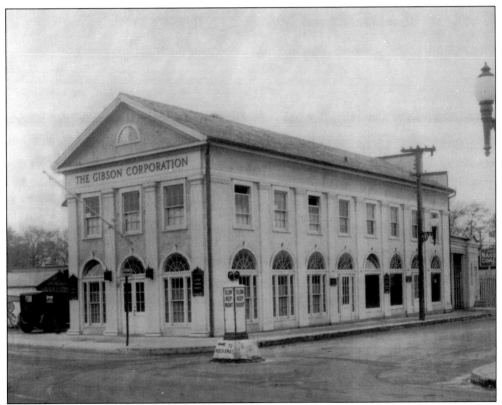

William Gibson set up his corporation's headquarters on the corner of Rockaway Avenue and Roosevelt Avenue. The building still stands today and is an Italian restaurant. Note the traffic light in the middle of the road, and the old streetlight in the foreground on the right. (Courtesy of the Valley Stream Historical Society.)

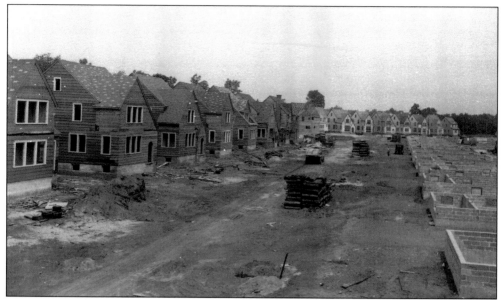

In the 1920s, developer William Gibson started building houses in the southern section of Valley Stream. His Gibson Corporation populated the area between Rockaway Avenue, Roosevelt Avenue, and Mill Road, and he even convinced the South Side Railroad to make stops at a new Gibson Station. His signature house, the Gibson Colonial, can be seen being produced en masse in this photograph. (Courtesy of the Valley Stream Historical Society.)

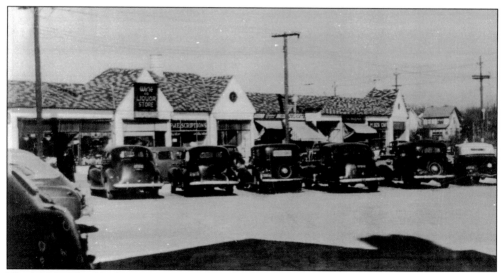

The crossroads of Dubois Avenue and Gibson Boulevard (originally Linden Street) became the center of the Gibson section. This photograph, taken in 1935, shows some of the shops that set up along the center. The one on the far right was Goldie's until recently. Gibson Station sits right behind the photographer. (Courtesy of the Valley Stream Historical Society.)

Development had been taking over many formerly green spots in the village, but the two in this photograph from 1946 at the crossroads of Sunrise Highway and South Franklin Avenue are still in existence. Memorial Park, on the northwest side of the intersection, in front of the elevated train station, is still a park today (though landscaped differently). On the south side of the road, the green area is Mill Pond (today Edward Cahill Park). In this picture, note the Gibson homes sign where Staples is today and the old mile marker on the right side. (Courtesy of the Nassau County Police Museum.)

This bucolic view of Gibson shows Cochran Avenue before the 1927 development of the street. Foster's Brook runs underneath the bridge that crosses Cochran Avenue, up past the old Foster homestead around today's Brookside Drive and Brush Drive. The south of Valley Stream was filled with streams and brooks leading to ponds and lakes. In the 1920s, the Ku Klux Klan burned crosses in this area to intimidate the Irish Catholics in Gibson. (Courtesy of Barbara Gribbon.)

Dubois Avenue in Gibson appears on many old maps before the development of the area as Hay Path. The route went through the property of the Queens County Water Works, which purchased the area surrounding Foster's Brook prior to Gibson's development. These large Colonials on Dubois Avenue were built before William Gibson built up the area and stood apart from the normal Gibson houses. (Courtesy of Barbara Gribbon.)

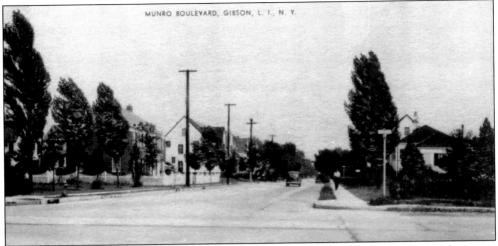

Unlike the Rockaway Avenue and Rockaway Parkway sections of Valley Stream, Gibson was not set up in a grid-like pattern. Roads in Gibson had a tendency to curve and stretch diagonally towards the center with the railroad station. Munro Boulevard, seen in this photograph, starts at Rockaway Avenue (near its current intersection with Peninsula Boulevard) and runs at an angle towards Gibson Boulevard (originally Linden Street) at Gibson Station. (Author's collection.)

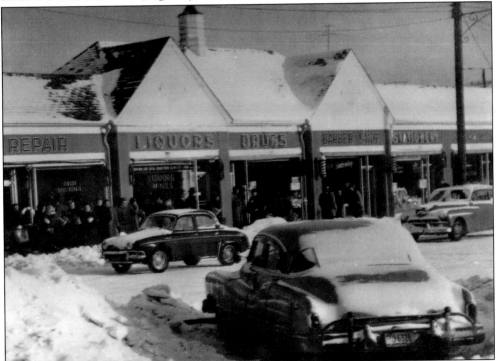

The row of stores on Dubois Avenue at Gibson Station has been the center of the community since its construction. William Gibson laid out the area so that a row sits on each side of the tracks on Dubois Avenue between Cochran Place and Gibson Boulevard and another row (which included an A&P) sits on Gibson Boulevard south of the station. Stonies gas station and auto body opened next to the station house, greeting passengers when they get off the train. (Courtesy of KKG Automotive.)

Gibson Station, Long Island
153-55 DuBois Avenue . Valley Stream, N.Y. . Phone (516) VA 5-7063, VA 5-7064

In 1962, Alberto Francesco Natale Occhiuzzo opened Goldie's in Gibson Station. Occhiuzzo filled the restaurant with pictures and paintings of clowns, a fascination of his, evidenced by this 1980s menu. Over the years, many notable jazz musicians appeared there, including Duke Ellington and Doc Severinsen. In January 2014, Occhiuzzo (whose nickname was Goldie) passed away of natural causes at the age of 90. Shortly after, Goldie's closed its doors after 52 years of operation. (Courtesy of the Long Island Studies Archive at Hofstra University.)

Six

GREEN ACRES

This is a 1953 advertisement for new ranch-style homes on Curtiss Field and the unincorporated Hungry Harbor area of Valley Stream. The Chanin Organization named the area Green Acres and started selling 1,800 single-family homes in the 1940s for a little over $16,000. Chanin also planned for the current Green Acres Shopping Mall north of the property. Many years later, the community changed its name to Mill Brook. (Courtesy of the Long Island Studies Archive at Hofstra University.)

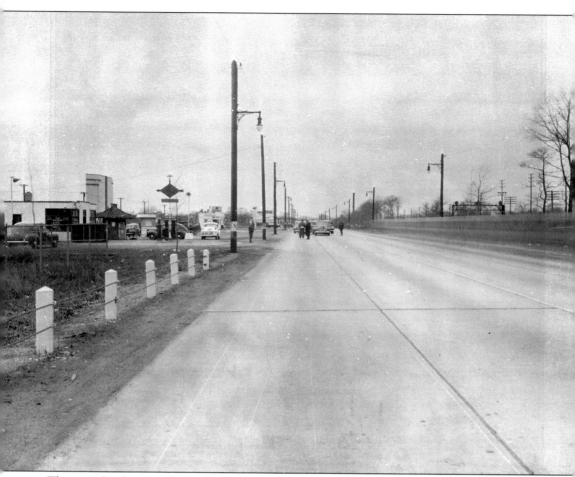

The area that became Green Acres was originally the 76-acre property of Frederick Reisert in Hungry Harbor from the aqueduct to the Mill Stream. In 1928, Rogers Airport opened up south of the newly built Sunrise Highway. On April 7, 1929, the property changed to Curtiss Field and provided commercial and passenger airline service, making it the most popular airfield on Long Island in 1930. This shot from 1941 looks west down Sunrise Highway toward Rosedale, past the Curtiss Field properties. On the left there is an old Sunoco sign and station and an old Mobil gas sign in the far back. Also on the left is the Sunrise Drive-In Theatre, which opened on August 16, 1938. It was the first open-air drive-in theater in New York State and could hold 500 cars. The drive-in was demolished in 1979 and replaced by the Sunrise Multiplex Cinemas. (Courtesy of the Nassau County Police Museum.)

Before closing due to the Great Depression in 1933, Curtiss Field made flight history. Jimmy Doolittle made the first all-blind flight from Curtiss Field. Coste and Bellmonte landed there in 1930 after their flight from Paris. Charles Lindbergh and Wiley Post made the field their headquarters. This 1948 photograph shows the land reuse after the dissolution of the airfield. (Courtesy of the Nassau County Police Museum.)

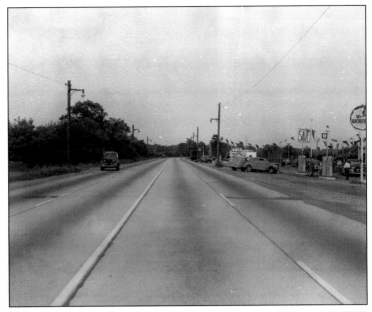

In 1933, the Curtiss-Wright School of aeronautics opened in the hangers but closed in December of that same year. The six hangers were taken over by Columbia Aircraft in 1942 for production of military planes. Here, in 1941, Jacob Schulman, who ran a cooperage and barrel-maker at 233 North Central Avenue, parks his truck at Hanger Three before Columbia took over the site. Schulman's barrel shop is currently an antiques shop. (Courtesy of the Nassau County Police Museum.)

The Women's Pilot Association, also known as the Ninety-Nines, is pictured at Curtiss Field on their founding in November 1929. The group was created to promote the advancement of female pilots and was named for the number of members in their organization. Their charter members included Amelia Earhart, Nancy Bird Walton, and Betty Gillies. Pictured are, from left to right, (first row) Viola Genry, Mrs. Theodore Kenyon, Wilma L. Walsh, Frances Harrell, Meta Rothholtz, and Fay Gillis Wells (flight suit). The rest are unidentified. (Courtesy of the Nassau County Photo Archive.)

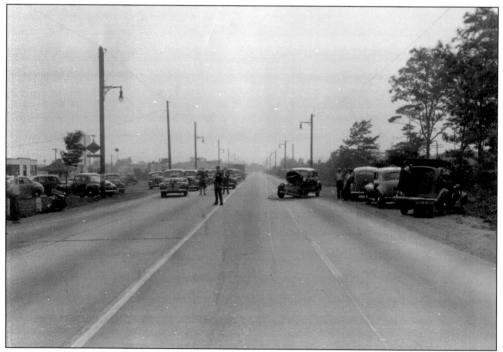

A car accident by Hook Creek Boulevard in 1939 blocks a lane of traffic on Sunrise Highway. In the background, the new Sunrise Drive-In Theatre is playing *Divorce of Lady X*, starring Merle Oberon, and *Son of Frankenstein*. (Courtesy of the Nassau County Police Museum.)

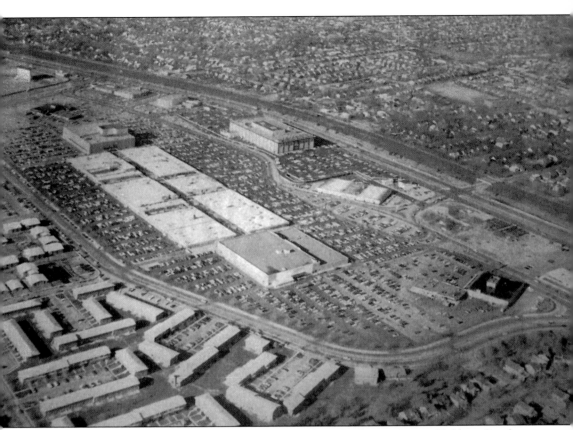

The Chanin Organization opened Green Acres Mall on the former Curtiss Field on October 7, 1956. There were 73 retailers in the open-air mall, including Gimbels (the far anchor), F.W. Woolworth's, J.J. Newberry, Sam Goody, Regents Men Shop. and J.C. Penny. This photograph from 1967 shows the later addition of Love's (originally Lane's) and Dime Savings Bank as the eastern anchor store. Two outer parcels to the mall include a Grand Union Supermarket (dark roof at near right) and National Foods, later Finest (far left, beyond Gimbels). On the extreme upper left, one can see the Sunrise Drive-In and, in front of that, The Patio nightclub. The major buildings on Sunrise Highway are Cooky's Steak Pub, Green Acres Century Theatre (opened in 1961 and recently demolished), Alexander's (opened in September 1967, demolished in 1992), Green Acres Bowl, Fisher Real Estate, and the House of Chang. (Courtesy of Green Acres Mall.)

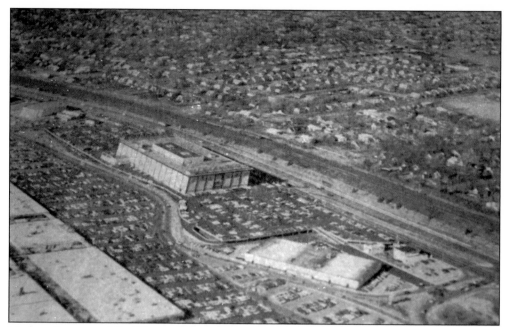

Nathan Serota and Ike Elias built hundreds of houses and shopping centers on Long Island, making a name for themselves as the architects of suburbia. In 1964, Serota purchased land on Sunrise Highway owned by the New York City Waterworks, outbidding the Chanin Organization. Chanin made several offers to buy the land from Serota, but he refused, and on September 18, 1967, Serota and Elias opened a new Alexander's department store on the site. In an act of revenge, Chanin built a "spite fence" around the border of their properties so no one could travel between them directly, pictured above. Alexander's closed in June 1992 and was demolished. Below, Ike Elias and his wife, Molly, pose outside another of Elias's properties in Elmont in the early 1960s. (Above, courtesy of Green Acres; below, courtesy of Martin Elias.)

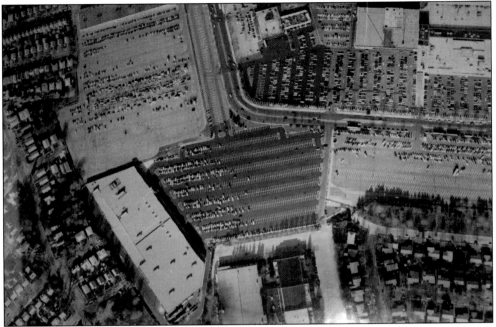

By the late 1980s, many of the former Curtiss Field hangers were still standing. After Commonwealth bought Columbia Aircraft in 1946, production of planes ended within a year. Bulova Demco moved their headquarters and factory into one of the hangers and stayed there for some time. The hangers were torn down in the early 1990s, and in May 1994, a Home Depot opened on the site. (Courtesy of Green Acres.)

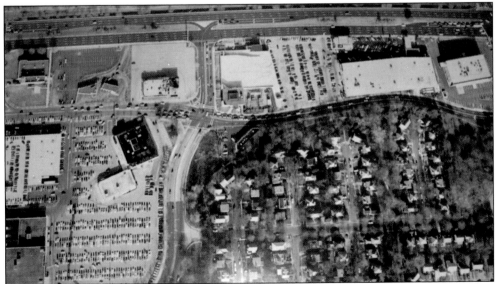

The corner of Sunrise Highway and Mill Road was developed in the 1950s. The corner building began as a Safeway Market, later becoming a Herman's Sporting Goods. Floyd Bennett's opened in an adjacent store (an offshoot of the Brooklyn brand) and became a Toys "R" Us in the late 1970s. The properties are in the incorporated village rather than Green Acres. (Courtesy of Green Acres.)

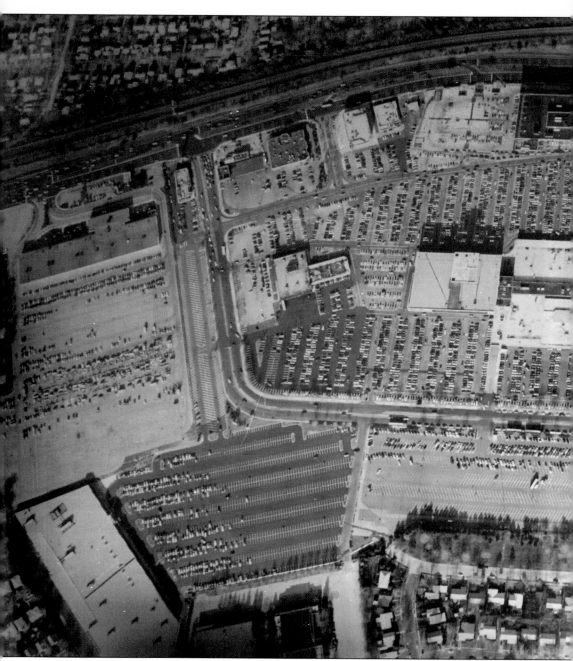

This aerial photograph from 1991 shows the evolution of the mall since the 1960s. The mall's open-air midway was roofed in 1970, and in 1983, a new wing (featuring anchor Sears) was added, as well as a second floor and a 14 bay food court. Next to Sears, a parking garage and a Sears auto center were built. Gimbels was replaced with Abraham & Strauss in 1986, which became a Macy's in 1995. On Sunrise Highway, the drive-in was demolished for the Sunrise Multiplex, Cooky's became Crazy Eddie's, a Red Lobster opened (originally Aunt Jemima's Pancake House),

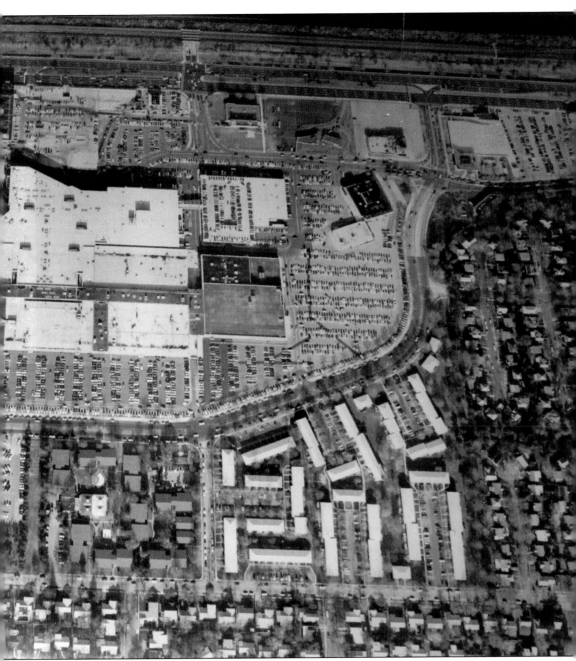

the bowling alley was torn down, House of Chang became Nobody Beats The Wiz, a Dime Savings drive-up was installed, Floyd Bennett's became Toys "R" Us, and Herman's Sporting Goods on the corner of Mill Road would become an office building. Kids "R" Us had taken over the Grand Union space. In the far back, Bulova Demco was using the Columbia hangers from Curtiss Field. They would soon be demolished for a new Home Depot. (Courtesy of Green Acres.)

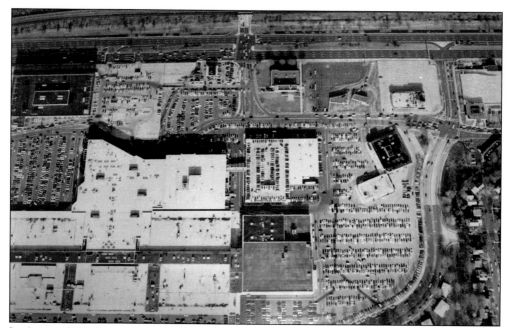

In August 1982, Green Acres Mall built a new wing and second floor with a Sears anchor store. Seen in this picture, the Sears wing juts out of the main mall, connected to a three-level parking garage and the Sears Auto Center. This image also shows the lot that was formerly the Green Acres Bowling Alley, now a parking lot. (Courtesy of Green Acres.)

William F. Florio of Valley Stream's Cantina Café demonstrates different foods available in his restaurant at the Gimbel's Food Show in 1981. Gimbel's at Green Acres Mall traditionally invited local restaurants to demonstrate their foods with their equipment to promote Gimbel's housewares items. (Author's collection.)

Seven

MOVING TOWARD TODAY

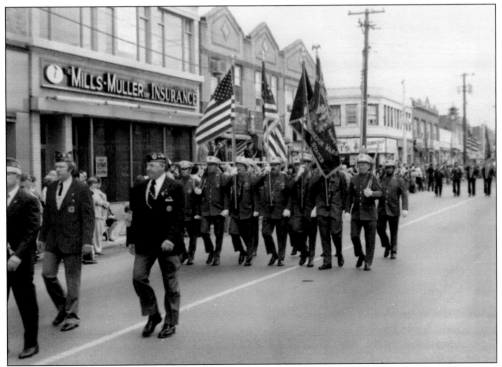

The Veterans of Foreign Wars march down Rockaway Avenue in one of Valley Stream's Memorial Day Parades in the early 1970s. Take note of Giancola's Paints in the background, the empty library building, and in the far back, the Brancard's Deli hanging sign. (Courtesy of VFW Post 1790.)

Herb Wetanson of North Woodmere started Wetson's in 1959 as a New York area competitor to White Castle. He had gone to California in the early 1950s and learned how to run a fast-food business from the McDonald brothers, shadowing them as they produced hamburgers. Wetson's had two locations in Valley Stream; the first location, at 130 Sunrise Highway on the corner of Stewart Place, was only a take-out stand with no seating. A second location opened in 1970 on the corner of Rockaway Avenue and Sunrise Highway and was a sit down location. The sit-down location closed in 1975 to become a Roy Rogers. A McDonald's currently operates there. Wetson's had their corporate headquarters in Valley Stream at 107 South Central Avenue. Later, the office became the corporate headquarters for Cooky's Steak Pub and the law offices of Minerva and D'Agastino. (Courtesy of Arthur Wachtel.)

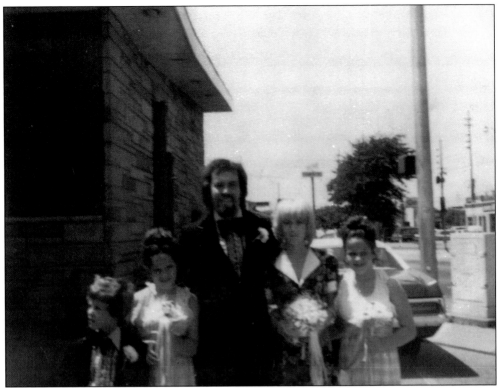

Donald Pupke owned the Coral Inn at the triangle between Brooklyn Avenue, Sunrise Highway, and Fifth Street since the late 1940s. The restaurant and catering hall hosted many weddings and events until it closed in the late 1970s, becoming Carlucci's supper club and later Legz, a nightclub and disco. A number of punk bands, including the Cro-Mags, played Legz in the early 1980s until it was torn down in 1983 for an office building. (Courtesy of Patrick Enright.)

CARLUCCI'S

SUPPER CLUB AND RESTAURANT

COMPLETE DINNER **5**95
Italian & American SUN. - THUR
ASK CARL FOR HIS FAMOUS GARLIC BREAD
(ON THE HOUSE)

DANCING WED. THRU SUN
FROM *THE FABULOUS*
VEGAS... **MIKE DANTE TRIO**

EVERY WED. NITE - YOU CAN
CATCH A RISING STAR—FRESH
COMICS— EXCITING SINGERS — GUEST STARS

SPECIAL ATTRACTION

THURSDAYS
GONG SHOW
CASH PRIZES

GOOD OR BAD - SIGN UP

ALFREDO

THE ROMANTIC SINGING SENSATION

WED & SUN
COMPLIMENTARY BUFFET
SINGLES INVITED
• UNESCORTED LADIES •
DRINKS ½ PRICE

WE CATER TO ALL PARTIES
516-561-7611
SUNRISE HWY. AT ROCKAWAY AVE., VALLEY STREAM

In the late 1970s, Carrlucci's took over the space that was Donald Pupke's Coral Inn. The supper club was known for its entertainment, including local singer Alfredo Villoldo. A few years later, Legz would take over the space. (Author's collection.)

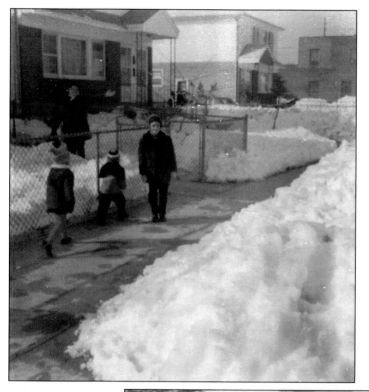

A nor'easter hit the Mid-Atlantic in 1969, and Valley Stream did not escape unscathed. At left, Valley Stream residents Antoinette Soscia (in back), Barbara Soscia, Edward Russo, and Michael Soscia enjoy a snow day. Below, the nor'easter of 1969 left many in Valley Stream digging themselves out of snow. Prior to shoveling, the snow reached up the side of this Ford. (Both, author's collection.)

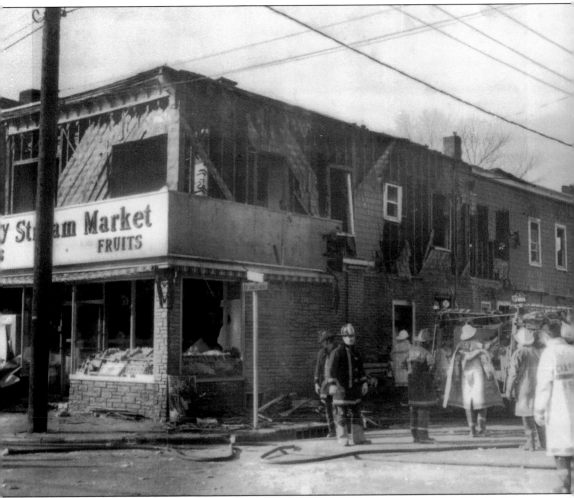

Firefighters were called to the scene of a fire at the Valley Stream Market in 1973. The building on the corner of Rockaway Avenue and Jamaica Avenue was torn down and reopened in 1974 as the site of Ancona Pizza, Lady Orlene Fashions, and three apartments. In 1977, Lady Orlene Fashions closed, and the store area was added to Ancona Pizza. (Courtesy of Ancona Pizzeria.)

By the 1970s, the old Pagan Homestead was on the verge of being demolished. Years of neglect left it derelict, as seen in this 1977 photograph. Valley Stream took over the home and allowed the Valley Stream Historical Society to make repairs. In 1983, the homestead was placed in the National Register of Historical Places as the Pagan-Fletcher Restoration. (Courtesy of the Valley Stream Historical Society.)

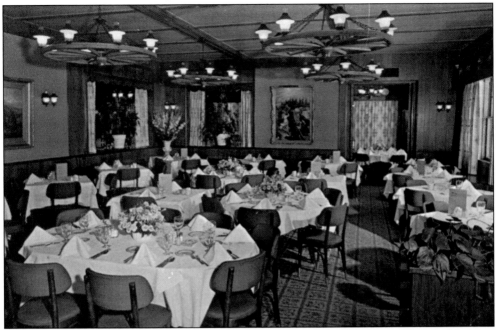

Edouard's Restaurant took over the location of Peter Lugar's Steakhouse on Sunrise Highway between Brookside Drive and Seventh Street in the 1940s. The restaurant would later Anglicize their name to Edward's Restaurant, and in the late 1960s, it became the Villa Marbonna. On the west side of Seventh Street was the Gateway Inn, which became The Publick House in the early 1970s. In 1984, both restaurants were torn down for Nathan Serota's five-story building. (Author's collection.)

Aaron Beecher built his first used car lot on the south side of Merrick Road in 1955. In 1966, he added a Chrysler dealership on the same property. It transitioned to Toyota in the mid-1980s after Beecher moved his Chrysler operation across the street (where it continues today as ABC Motors). His original dealership, pictured here, was demolished in the mid-1990s. Beecher died in September 2013. (Author's collection.)

These late-1960s wedding photographs outside the East Jamaica Avenue entrance of Holy Name of Mary church include some of the old houses on the street, few of which are no longer standing. In the above photograph, note the novelty warehouse in the back on South Cottage Street. It would become Daniel Lerner's In-Flight Magazine and is currently condominiums. In the photograph below, take note of the bungalow set far back in the lot. (Both, courtesy of Dan King.)

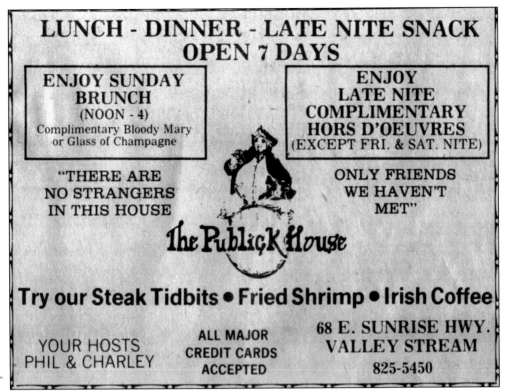

In the early 1970s, the longtime Gateway Inn at 68 East Sunrise Highway, on the corner of Seventh Street, changed to The Publick House. The watering hole became one of the most popular in the village as the gathering place of college students when they came home for holidays. The Publick House sold their building in 1984 to Nathan Serota, who tore it down to construct an office building. (Author's collection.)

The incorporated village border crosses through the intersection of North Corona Avenue and Rockaway Parkway (a dream Robert Dibble had as early as the mid-1920s). This photograph from the 1970s shows the welcome sign as well as a water fountain in the background. That fountain has since stopped running and is now a plant pot. (Courtesy of Peter and Beryl Bauer.)

117

The Italian American Civic Association of Valley Stream accepts a flag flown over the Capitol in Congressman John W. Wydler's office. Pictured from left to right are Fay Harrison, Rae Gubitossi, William F. Florio, and John W. Wydler. (Author's collection.)

The influx of Italians to Valley Stream in the early 20th century led to the formation of the Italian American Civic Association of Valley Stream in 1971. Seen here at the installation dinner in 1977 are, from left to right, Frank Giaquinto, James Rossi, the Honorable Frank X. Gulotta, Rae Gubitossi, unidentified, Silvio Locastro, and unidentified. (Author's collection.)

Crossing guard Maryanne Cahill was a fixture on the corner of Jamaica Avenue and Rockaway Avenue for years. Here, she poses in the late 1970s with a horse. Note the old signs for Larry's Pub and Charles Kornfeld Photography in the back. The corner has been renamed Maryanne Cahill Corner. (Courtesy of Maryanne Cahill.)

Future Valley Stream mayor Edward Cahill meets Pres. Jimmy Carter when his plane touched down at LaGuardia Airport. Before becoming mayor, Cahill was a member of the New York City Police Department. He died on July 31, 2010. (Courtesy of Maryanne Cahill.)

Cantina Café opened in 1970 at 64 East Merrick Road, on the corner of South Cottage Street. The bar was built in the basement of the added front to the 1920 pre-incorporation Colonial house on the property. After closing in 1985, the building became home to Cameo Real Estate, Tivoli Travel, Blinds to Go, Ray Cooper Real Estate, Action Pipe, and currently MC Collision. (Author's collection.)

Cantina Café had regular entertainment on weekends, including Pat Donahue, Joe Virga, Ethan Roberts, Jim Kelly, Robert McCormic, and Vinny Virga. This photograph shows the entertainment during the opening weeks of Cantina Café. (Author's collection.)

After it stopped showing films in the 1980s, the Rio Theatre became a mecca for rock shows, hosting Aerosmith, Metallica, Slayer, Hot Tuna, and more, often tying in promotions with Slipped Disc across the street. By the 1990s, it was boarded up and left to rot. There was an attempt to transform it into a shopping mall in the early 1990s, which did not come to fruition. Ultimately, the Rio was demolished in 1997, and a dialysis center sits on its site today. (Author's collection.)

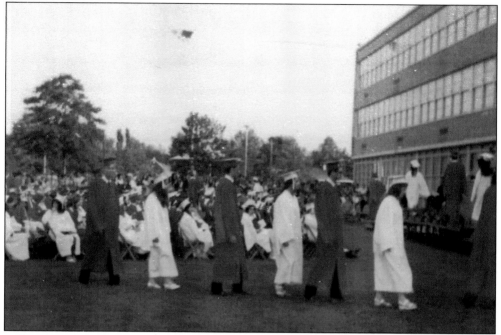

Valley Stream South Junior and Senior High School was opened in 1955 to accommodate the students in the southern part of the Valley Stream Central High School District. Valley Stream North Junior and Senior High School was opened up to accommodate the students in the northern part. These photographs capture the commencement ceremony at Valley Stream South Junior and Senior High School in the late 1960s. (Both, author's collection.)

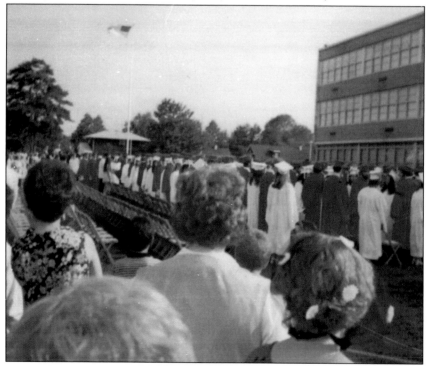

The Raustein Gas Station was located at 139 North Corona Avenue between West St. Mark's Place and West Argyle Street near Arthur J. Hendrickson Park. The pump had been in operation since the early days of the 20th century until 1984 when the property was sold to a developer who built the Theodore Court development. The station house was moved to the back of the Pagan-Fletcher Restoration where it sits today. (Author's collection.)

Hurricane Gloria struck Long Island in 1985, causing extensive damage across the area. Many trees fell down, knocking over power lines and keeping some Valley Stream residents powerless for a week. This damage was seen at the corner of Delmonico Place and Woodlawn Avenue. (Author's collection.)

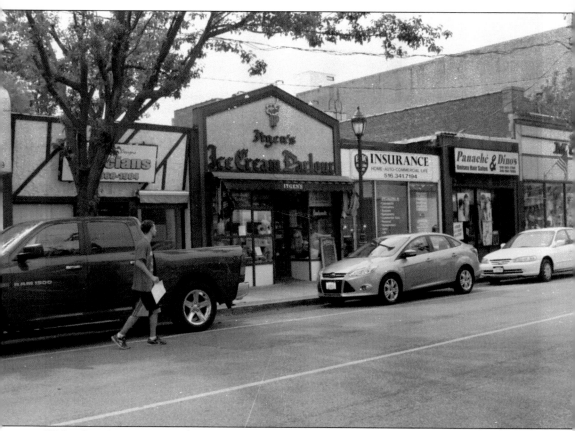

Walter Itgen's ice cream parlor on Rockaway Avenue between Jamaica Avenue and Hawthorne Avenue has been in the same location for decades. The building first became an ice cream parlor in the 1920s under the name Teddy's Sweet Shop. In 1938, James Mitchell, a worker there, took over Teddy's Sweet Shop. He changed the name in the late 1950s to Paul's Ice Cream Parlor, eventually selling the building to Itgen. Mitchell moved across the street and opened Mitchell's on the west side of Rockaway Avenue in the mid-1960s. Mitchell moved again to the east side of Rockaway Avenue between Jamaica Avenue and Valley Stream Boulevard only a few years later. (Author's collection.)

Edward Lieber's funeral home refurbished the outside of their East Valley Stream Boulevard building over the years, moving towards its current appearance. Some time later, they opened a second location on North Central Avenue to accommodate an increase in business. The building is one of the oldest still standing in Valley Stream. (Courtesy of Lieber Funeral Home.)

In the 1990s, the village redid all the sidewalks of Rockaway Avenue, adding red bricks and stylish lights and benches to improve the downtown area's aesthetics. In the background, barbers from Sal & Vin's Barber Shop watch. Sal & Vin's has been servicing Valley Stream residents since 1952 and is still going strong to this day. Longtime Valley Stream business Phil Amy Florist has since left this space since this photograph was taken. (Courtesy of Sal & Vin's.)

Ferdinando "Freddy Frogs" Toscano moved to Valley Stream from Brooklyn in 1968, bringing with him a fascination with doo-wop and rockabilly music. In 1973, he and his sister Marie Toscano opened Frogs on Rockaway Avenue between Lincoln and Fairview Avenues in the former location of Suprina's Sportland. In the late 1970s, Frogs had the first Ticketron electronic box office in Valley Stream, and fans lined up around the block to purchase tickets for the Rolling Stones Madison Square Garden Show, as captured in these photographs. Though Frogs closed down in the early 1980s, Toscano maintained his presence in Valley Stream, playing in numerous bands around the village, including Buckley's under the railroad track. Sadly, Toscano died on May 10, 2009, but his influence lives on. Brian Donnelly has started a rockabilly festival and car show in his honor and has dedicated the stage at Buckley's for Toscano. (Both, courtesy of Marie Roman.)

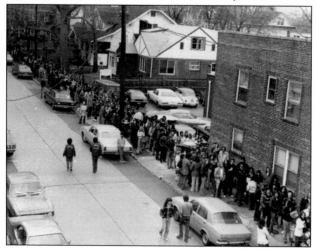

Michael Schutzman opened Slipped Disc in Frog's location on March 1, 1982, as a specialty store for punk, heavy metal, and hardcore music. Slipped Disc achieved legendary status, bringing in many metal acts such as Metallica, Slayer, Dio, Motörhead, and Megadeth to sign autographs, usually before playing across the street at the Rio Theatre. During the 1980s, with offbeat businesses such as Frogs, Slipped Disc, Legz, and the Rio Theatre all up and down Rockaway Avenue, Valley Stream earned the moniker "The East Village of Long Island." On April 19, 2008, Slipped Disc closed due to rising real estate rates. Schutzman still uses the Slipped Disc name and appears at record shows regularly. The location is now Sip This, a coffee house run by Stephanie Pontillo and David Sabatino. (Both, courtesy of Michael Schutzman.)

Discover Thousands of Local History Books
Featuring Millions of Vintage Images

Arcadia Publishing, the leading local history publisher in the United States, is committed to making history accessible and meaningful through publishing books that celebrate and preserve the heritage of America's people and places.

Find more books like this at
www.arcadiapublishing.com

Search for your hometown history, your old stomping grounds, and even your favorite sports team.

Consistent with our mission to preserve history on a local level, this book was printed in South Carolina on American-made paper and manufactured entirely in the United States. Products carrying the accredited Forest Stewardship Council (FSC) label are printed on 100 percent FSC-certified paper.

MADE IN THE USA